SNYDER C

SPORTS HERITAGE

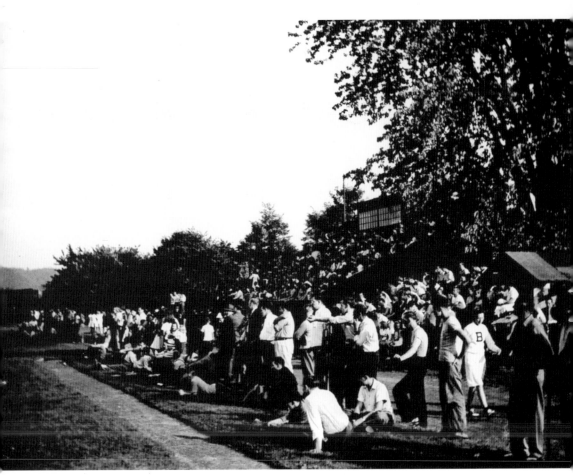

To Snyder Countians, playing the game is important, but just as important is supporting those who play—as shown by the standing room–only crowd at this early-fall 1941 Selinsgrove Seals vs. Bloomsburg Panthers high school football game played at Susquehanna University's field. This book is meant to honor those who participate and those who lend support.

On the front cover: Neal Smith went from walk-on to consensus football All-America as a Pennsylvania State University safety in 1969. (Courtesy of Penn State Sports Information.)

On the back cover: Pictured here is the 1973 West Snyder High School boys' soccer team that won the Pennsylvania Interscholastic Athletic Association (PIAA) state championship. At this time, there were no levels of competition—schools from all divisions played in the one and only state tournament. (Courtesy of Jerry Botdorf.)

Cover background: Please see page 97. (Courtesy of the Susquehanna University Archives.)

SNYDER COUNTY'S SPORTS HERITAGE

Jim Campbell

ARCADIA
PUBLISHING

Published by Arcadia Publishing
Charleston SC, Chicago IL, Portsmouth NH, San Francisco CA

Printed in the United States of America

Library of Congress Catalog Card Number: 2006923706

For all general information contact Arcadia Publishing at:
Telephone 843-853-2070
Fax 843-853-0044
E-mail sales@arcadiapublishing.com
For customer service and orders:
Toll-Free 1-888-313-2665

Visit us on the Internet at www.arcadiapublishing.com

CONTENTS

ACKNOWLEDGMENTS

This is the third in a series of Arcadia publications on Snyder County. As with the previous two, this would not have been possible without the cooperation of many, including members and officers of the Snyder County Historical Society. Those giving generously of their time, knowledge, and—most importantly—treasured photographs are: Randy Arbogast, Carolyn Arndt, Gary Aucker, Greg and Pam Aungst, Jim Aurand, Russell "Rusty" Baker, Chris Bailey, Lloyd and Shirley Bailey, Nelson Bailey, Vivian Beaver, Dave and Janell Becker, Rupert Becker, Jean Benner, Ray and Betsy Benner, Teresa Berger, Bob Bickhart, Dick Bogar, Denise Boonie, Gerald and Harriet Botdorf, Wilfred "Wimp" Boyer, Carolyn Burns, Brenda Campbell, "the real" Jim Campbell, the staff of Community Banks, Brendan Cornwell, Dave Davis, Bob Dunkelberger, Joe Epler, D. J. Ernst, Charles K. Fasold, Richard Felker, Leon Earl and Carol Fetterolf, Al Fisher, Joe Fopeano, Gertie Gano, Rudy Gelnett, John Getz, Bob Gift, Ann Good, Ann Groner, Bud and Ruth Herman, Ted Herman, Kayre and Alice Herrold, Charlie Hoover, Tiffany Howe, Fae Hunsinger, Verne Inch, Ethel Ann Jones, Carol Joyce, Tanna Kasperowicz, Jim Kauffman, Kevin Kearns, Barry and Jean Keiser, Cathy Keiser, Helen Keiser, Jim Keiser, Kay Keller, Jane Kessler, Terry Kissinger, Norman Kline, Ray Kline, Goldie Klinepeter, LaRue Knepp, Lee Knepp, Steve Knepp, Marlin Kratzer, Bob Kuster, Mary Laudenslager, Dave Lauer, Max and Ann Leitzel, Bill and Sally Lindsay, Don "Ziggy" Mattern, Tony McGlaughlin, Gibby Mease, Noreen Melaney, Pross Mellon, Barry Miller, Dale Miller, Ken Miller, Bill Moll, Don Moyer, Ray Moyer, David Mull, Harvey Murray Jr., Todd Myers, Rose Ann Neff, Ron Nornhold, Roger and Loris Pheasant, Joan Phelps, Betty Wenrich Pisano, Brian Pontius, Don Pontius, Jean Rathfon, Ann Reitz, Norman Rigel, Ruth Roush, Betty Schlingmann, Jane Schnure, Bill Scott, Dwight Saxton, Bob Shadle, Carey Sheaffer, Barry "Buzz" Siegfried, Jim Skinner, Neal Smith, Johnny Snyder, Ken Snyder, Bree Solomon, Bob Soper, Rita Steffen, the staff of the Susquehanna University library, Nancy Sweeger, Jim Taylor, Dave Troutman, Deb Troutman, John Troutman, Caralyn Van Horn, Erin Vosgien, Marlin Van Horn, Ken Wagner, Harold "Dieutch" Wagner, Bob Walker, Gene Walter, Joe Walter, Don Wilhour, Ken Wochley, Vaughn Wolf, Bob Yerger, Jim Youngman, and Jane Zimmerman.

INTRODUCTION

Going back to "the glory that was Rome" and "the grandeur that was Greece," we know from writings and artwork that sports, games, and recreation have been a part of civilization for nearly as long as there has been civilization. Depictions of running, wrestling, and boxing—as well as other sports—appear in the earliest documentation of ancient and daily life, even as far back as primitive illustrations by cavemen.

When Europeans first came to the shores of North America, they found Native Americans playing a game that closely resembles intercollegiate lacrosse.

What have evolved into sporting activities—hunting and fishing—were practiced by both Native Americans and the earliest settlers. At that time, though, these activities were more a necessity to maintain a livelihood than a sport. It was only natural that competition began: Who was the best hunter? Who caught the biggest fish? Who downed the largest buck or bear? Who bagged the most pheasants or ducks?

From those early times, we have progressed—if that is the proper word—to hundreds of games and competitions, to organized teams, and ultimately to "all sports all the time" television.

Early Dutch settlers brought bowling to America's shores in the earliest days of the colonies. Many villages had a bowling green, where the sport was played out of doors. In fact, so popular was the sport that at least two states (Kentucky and Ohio) have a town named Bowling Green.

The 329 square miles that many of us call home—Snyder County—is no different from other parts of our nation. Sports evolved here much as they did elsewhere. In the 1740s, when the area was first settled, there was precious little time for sport, as such. But skills as hunters and fishers, skills that later would stand those who participated in good stead, certainly were honed and refined.

As our forbearers tamed the land, so to speak, there actually was some time for recreation, nothing too frivolous but still a respite from the usual back-breaking toil of the day. Baseball, although not invented/developed by Abner Doubleday—as so long thought to have been, courtesy of a myth—first took hold after the Civil War. General Doubleday fought at the Battle of Gettysburg, incidentally.

In Snyder County, there is photographic and written documentation of baseball being played well before the dawn of the 19th century. It is, undoubtedly, the county's longest-played organized sport at all levels of competition. From town teams to high schools and academies (and the county's lone college) to youth and Little League teams, the sport has become ingrained in Snyder County life. Combining baseball with softball, not too many county residents can claim never to have picked up a bat, a ball, or a glove. Oddly enough, high school baseball took longer to catch on than might be thought. Given the relatively short school year (sometimes over in early April to help with the spring plowing and planting) and the unpredictable weather, there simply were not enough days conducive to playing a full schedule of baseball games. It was well into the 1900s that high school baseball became a staple on the sports menu. This is not to say that nonschool teams did not compete throughout the summer months. Even with the proliferation of high school and youth soccer, it is almost a sure thing to say that more county residents have participated in baseball and softball over the years than in any other sport.

Selinsgrove was the first, and to this day the only, Snyder County high school to field a football team. Other county schools simply did not have the enrollment to support a program. Begun in 1926, Selinsgrove High football experienced nearly unequaled success under Harold L. "Pete" Bolig. Over the years, Selinsgrove football has had its ups and downs, but for the past three decades, Bill Scott has produced consistent winners and playoff contenders.

Susquehanna University first ventured onto the gridiron in 1892 under coach George E. Fisher, compiling a 0-2-2 record. With many homegrown Snyder County products, the Crusaders have had their share of gridiron glory. Among the most noteworthy periods were when "the Grand Old Man of Football," Amos Alonzo Stagg Sr., co-coached with his son Amos Alonzo Jr. (1947–1952) and produced an undefeated season in 1951, and the golden era of coach Jim Garrett (1960–1965), when the orange and maroon, at one time, held the longest active winning streak in the nation.

Soccer began at Beaver Vocational and Middleburg High Schools in the late 1920s under Arthur Townsend and Carl E. Slaybaugh. The other Snyder County schools, except Selinsgrove, also field soccer teams. Middleburg and West Snyder, which came into existence in 1955, quickly became intense rivals—as had McClure and Beaver Vocational. One has to wonder if West Snyder's winning of the 1973 PIAA state championship did not provide Middleburg High with extra motivation in the Middies capturing their own state championship the very next year—and this was at a time when all schools, regardless of enrollment, played in the one and only state tournament. Selinsgrove, thanks in large measure to Middleburg High alumnus Steve Steffen, is into its third decade of fielding soccer teams.

Basketball, invented by Dr. James A. Naismith in 1891, appeared in Snyder County not too long after that. Incidentally, Amos Alonzo Stagg Sr.—a student at the Springfield (Massachusetts) YMCA Training School where Naismith invented the game—played in the very first basketball game.

Track and field first took the form of an all-county field day at the scholastic level. The county's high schools, Selinsgrove, Shamokin Dam, Freeburg, Middleburg, Beaver Springs, Beavertown, Beaver Vocational, and McClure, participated in the one-day event from 1924 to 1937. In more recent times, Jim Taylor has produced two track and field dynasties (Selinsgrove, 1962–1972, and Susquehanna University, 1973–2000). Don Wilhour only added to the Seals' track and field laurels (1973–2000). Selinsgrove is the only county high school with a full-scale track and field program.

The Snyder County work ethic has produced many outstanding wrestlers at the scholastic level. The first wrestling program in the county was begun at West Snyder High School in 1956 under coach Jack Smith. The Mounties produced Snyder County's only NCAA Division I national champion, Gobel Kline, as a 152 pounder at the University of Maryland in 1969.

With the advent of Title IX legislation in 1972, which essentially said, "what you do for guys, you have to do for gals," girls' and women's sports saw a marked increase from occasional basketball and softball programs to a much fuller menu of activities.

Sports, games, and recreation—kept in proper perspective—can be truly beneficial to overall quality of life and can be enjoyed for a lifetime. The many adult bowling leagues in Snyder County attest to that. Wes Romberger, who lived to be 101, bowled regularly, throwing strikes into his 100th year.

The sports heritage of Snyder County is a rich one, indeed. It is hoped this volume does justice to the long-standing traditions.

FRIDAY NIGHT LIGHTS
AND SATURDAY'S HEROES

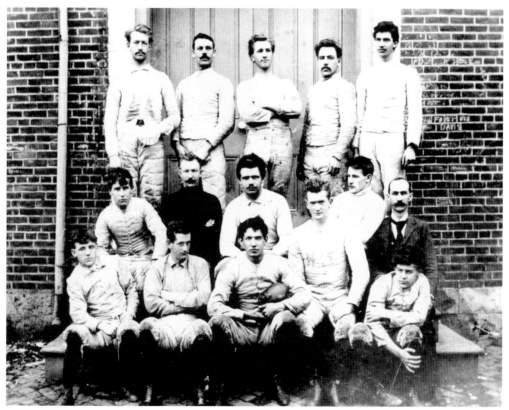

Historically college football began in 1869, when students from Rutgers and Princeton University met at New Brunswick, New Jersey. By 1892, football had spread to Susquehanna University. The following members of the first team are shown from left to right as follows: (first row) Harry Mitchell, Silas Rice, Robert Smith, W. C. McClintic, and Frank Woodley; (second row) Harry Hare, William Bastian, John Erhard, Sam Hare, and coach John I. Woodruff; (third row) William Rearick, William North, George Traver, Thomas Taggert, and William Crouser.

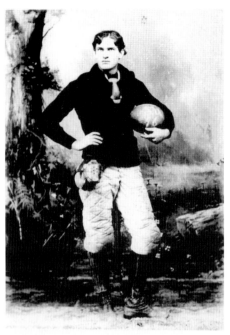

SELINSGROVE, PA.

At the beginning of the 19th century, Reuben L. Ulrich was one of several photographers operating in Snyder County. His studio photograph of an unidentified 1896 Susquehanna University football player classically illustrates gridiron toggery at the time—quilted pants, bamboo-reinforced shin guards, flimsy "head harness" (hooked on belt), and rubber nose protector (hanging from neck). The orange and maroon fashioned a record of three losses and one tie that season.

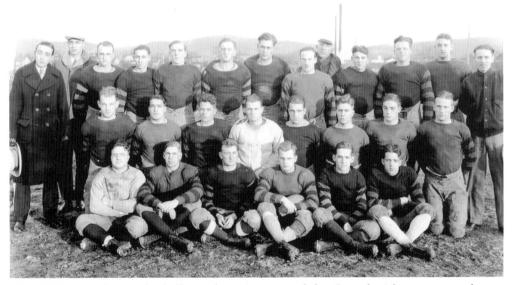

This 1925 Susquehanna football squad was not one of the Crusaders' better teams, despite being coached by Edgar Wingard, who led Louisiana State University in 1908 and Bucknell University in 1918 to undefeated seasons. Susquehanna University had a 1-6-2 record. Of note are two Selinsgrove players who became Susquehanna University legends and/or hall of famers: freshman halfback Willie Groce and senior halfback Harold L. "Pete" Bolig. They are shown side by side, Groce second from the right in middle row, and Bolig third.

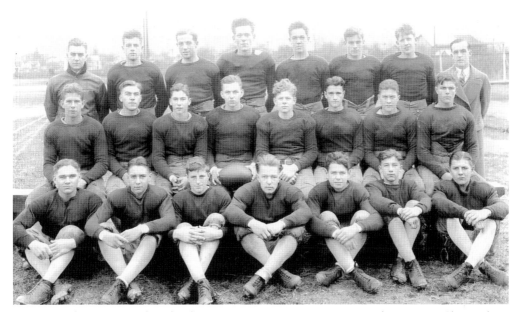

In 1928, Selinsgrove High School was a true juggernaut, going 8-0 that season. Shown from left to right are the following: (first row) Ralph Brouse, Saylor Neiswender, Bob Shadle, Earl Deckard, Claire Bendigo, Bob Roush, and Roy "Himmie" Bolig; (second row) Maynard Kemp, Ernie Row, Lee "Zip" Rishel, captain Al Ott, Fred Richter, Lance Bowen, Dick Forster, and Nelson Bolig; (third row) coach Harold L. "Pete" Bolig, Dave Kelly, Paul Bingaman, Henry Daubenspeck, Rich Fisher, Warren Groce, Seiler Phillips, and manager Laird Gemberling.

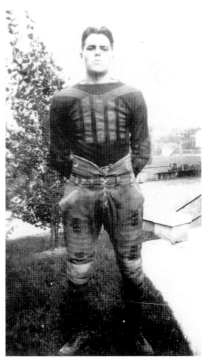

After graduation from Selinsgrove High School, and before matriculating at Duke University, Howard Schnure did a postgraduate year at Virginia's Staunton Military Academy. Pictured in 1928 at Staunton, the multitalented Schnure is described in the Selinsgrove High School Cynosure as being "a combination of Red Grange and Babe Ruth." Schnure was also a baseball pitcher of considerable talent.

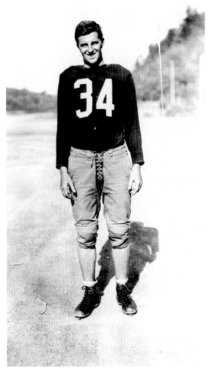

Bob Shadle was as fine an all-around athlete as Selinsgrove High School ever produced. He starred in football, basketball, baseball, and placed among the top finishers in the annual Snyder County track and field meet, competing against the high schools of Freeburg, Middleburg, Beaver Vocational, and McClure. After high school graduation in 1932, Shadle "prepped" a year at Bluefield College in Virginia (where he is depicted in this photograph) before enrolling at Gettysburg College.

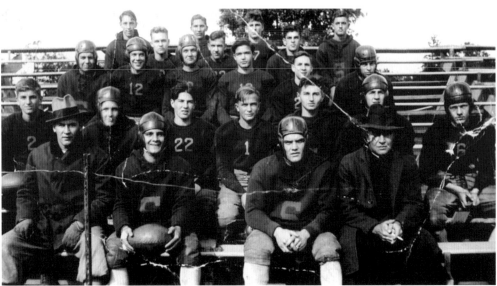

Harold L. "Pete" Bolig's 1934 Selinsgrove High team managed a 4-4-1 record. Shown from left to right are (first row) assistant coach Lee "Zip" Rishel, M. Sprenkle, W. Nichols, and head coach Pete Bolig; (second row) J. Shadle, M. Clark, J. Charles, B. Taylor, W. Steffen, J. Bolig, and P. Fisher; (third row) unidentified, unidentified, F. Machmer, C. Oldt, B. Diebler, and unidentified. The fourth and fifth rows are unidentified, but names found include Marks, Musselman, Morris, Slear, Baker, Troup, and Heim. Note coach Bolig's cigarette.

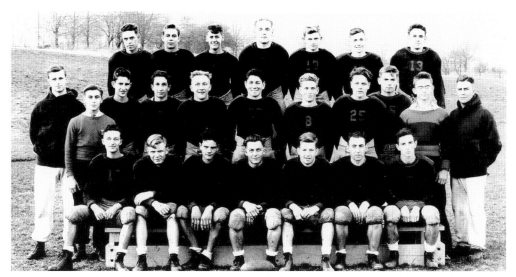

The Depression forced many students to drop out of school, but Selinsgrove High School continued to field teams under coach Pete Bolig. Shown from left to right are the Seals of 1939: (first row) G. Smith, C. Miller, B. Nichols, H. Beaver, M. Wilt, J. Schaeffer, and L. Steffen; (second row) assistant coach Bob Shadle, manager S. Wendt, B. Bolig, B. Herman, B. Haas, J. Dietzler, W. Roush, R. Nichols, J. Burns, manager P. Bingaman, and coach Pete Bolig; (third row) P. Laudenslager, S. Flickinger, F. Heimbach, J. Winners, M. Crebs, P. Sears, and P. Plummer.

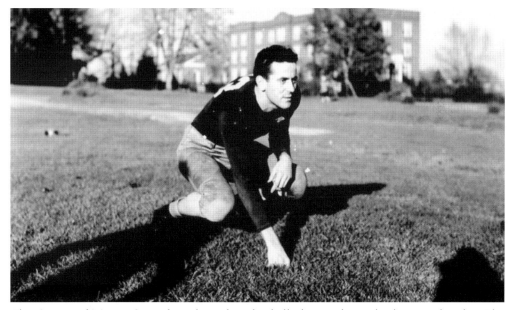

The Grecos of Mount Carmel are legendary football players, dating back many decades. The Greco name still appears on gridiron rosters in that Coal Region town. Joe Greco, pictured here, started it all. A key member of Susquehanna University's undefeated 1940 squad, he earned Little All-America honors as an end. He, like several of his football-playing sons, became a well-respected physician.

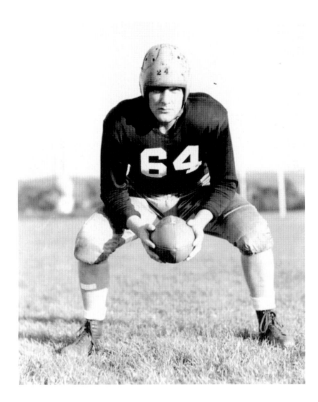

Bob McFall of Selinsgrove was a real gridiron warrior. After playing at Selinsgrove High School, he took his game to Susquehanna University, where he was a member of the 1940 undefeated Crusaders team. Other stops on his gridiron itinerary included St. Vincent, Dickinson Seminary (now Lycoming College), and Bucknell University. After combat service in the South Pacific (Iwo Jima and other island campaigns) with the 1st Marine Division, he played center and captained the semiprofessional Shamokin Indians.

Blair Heaton was a versatile athlete at Susquehanna University in the days before World War II. As an end, he called plays for the undefeated 1940 orange and maroon. He also starred in basketball and track and field. In 1943, what would have been his senior year had he not enlisted in the U.S. Army Air Corps, he was drafted by the Detroit Lions. Given the unsophisticated nature, or nonexistence, of NFL scouting in those days, this speaks volumes for Heaton's athletic ability.

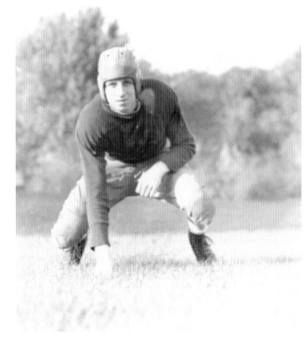

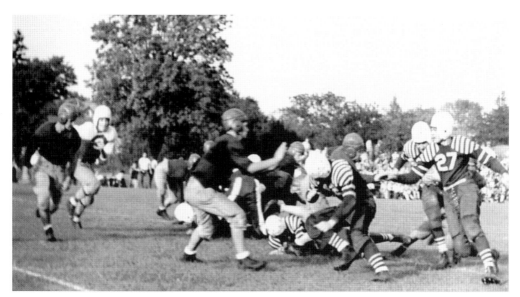

This photograph, like a considerable number of others in this book and previous Snyder County books, was taken by Charlie Fasold. County residents are grateful for the results of his hobby. The 1941 action photograph, a rarity for the time, depicts action between Selinsgrove High School and Bloomsburg High School. The Seals player identified (dark jersey, without stripes) is Bob Bolig (extreme left). Another Selinsgrove High School defender (center) is fighting off a Panthers blocker. The game was played at Susquehanna's University Field, now Stagg Field.

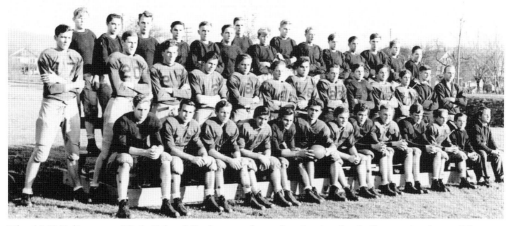

The 1943 Selinsgrove High School Seals were the only winning football team in almost 20 years. Shown from left to right are (first row) John Reitz, Glenn Hollenbach, Marvin Sprenkle, Lester Leach, Harold Aurand, Dave Coryell, Robert "Duffer" Sheetz, Charlie Jarrett, George Hummel, Ken Mease, Chet Rowe, Ellie Rowe, and ? Beaver; (second row) Rudy Nolder, ? Michaels, ? Sanderson, E. Boyer, ? Wilhour, Glenn Shaffer, ? Rathfon, George Shaffer, ? Wolf, ? Roush, ? Krouse, and coach Tom Valunas. The third row includes ? Brown, ? Marks, ? Maust, ? Day, P. Nolder, ? Tiner, ? Walshaw, ? Schultz, ? Kratzer, W. Boyer, ? Dressler, ? Burns, ? Duncan, and ? Laubscher.

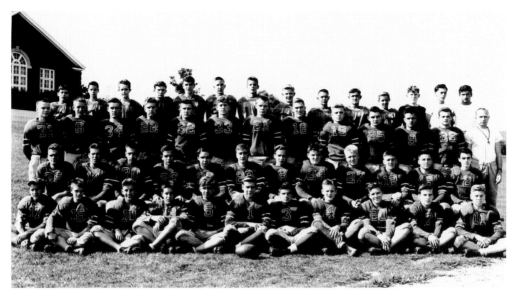

Selinsgrove High School's team of 1946, under revered head coach Tom Valunas, was better than the 3-5 mark they posted—four of the five losses were by only a touchdown. The Seals opened the season with a 7-0 loss to Lewistown, followed that with a 6-0 loss to Danville, and later in the season dropped tough decisions to South Williamsport (7-0) and Bloomsburg (14-7).

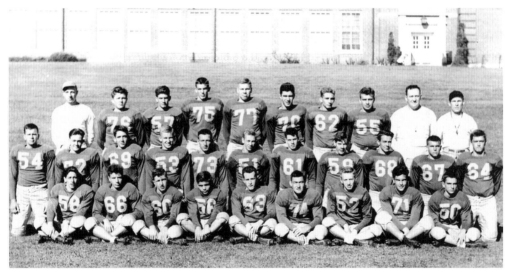

Selinsgrove High played under first-year head coach Dick Smoker in 1949. Short on luck, the team finished 3-6-1—four of the losses by seven or fewer points. Shown are, from left to right, (first row) Marlin Koch, Leon Brown, Howard Spigelmyer, Bill Adams, Lloyd Bailey, Elbert Wolf, Roger Hepner, Dale Booth, and Bob Longenberger; (second row) Lloyd Foreman, Ray Musser, Max Leitzel, Bill Bone, Jack Nace, Dick Kretz, Bill Gaglione, Ned Long, Ronnie Day, Raymond "Tots" Bitting, and Jim Van Buskirk; (third row) assistant coach Blair Heaton, Dave Ritchey, Bill Wendt, Jack Keller, Rupe Leohner, Ken Fahnestock, Bill Rowe, Earl Brown, Dick Smoker, and assistant coach Steve Jaworek.

With 300-pound lineman now in vogue in football, the term "watch-charm guard" has faded from football's lexicon, but that is exactly what Selinsgrove High's starting guards were in 1949. Elbert "Jim" Wolf (No. 74) and Lloyd Bailey (No. 63) both played at five feet six inches and 145 pounds. Both welterweights were multiyear starters for the Seals.

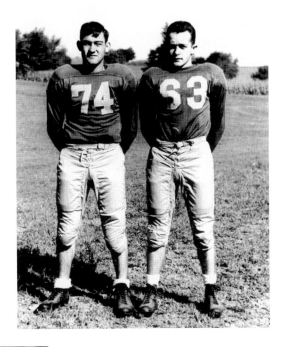

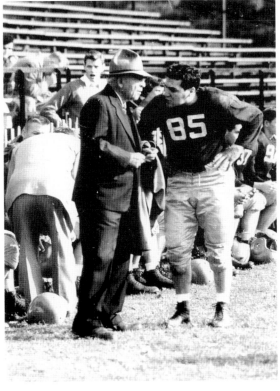

Felix "Phil" Torromeo, who came to Susquehanna University from West Orange, New Jersey, came mainly for a solid liberal arts education—he had a long and distinguished career as a school administrator. But part of the reason he and others chose to matriculate at Susquehanna was for the honor and privilege to come under the tutelage of Amos Alonzo Stagg Sr., "the Grand Old Man of Football." Torromeo listens intently as the Old Man imparts gridiron wisdom around 1950.

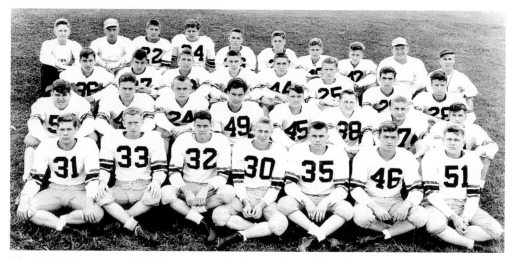

The 1950 Selinsgrove High School team had some fine athletes but managed only a 4-5 mark under head coach Blair Heaton. Shown are, from left to right, (first row) Ned Long, Reger Hepner, Bill Gaglione, Dick Kretz, Raymond "Tots" Bitting, Jim Van Buskirk, and Dave Ritchey; (second row) Don Leohner, Ray Musser, Lew Driver, Dale Booth, Wally Townsend, Clair Sprenkle, Bill Rowe, and Tom Aungst; (third row) Al Nace, Don Holtzapple, Sam Stauffer, Jerry Soper, Max Leitzel, Oren Brungart, Bob Longenberger, and Leon Brown; (fourth row) Gene "Rip" Van Winkle, Blair Heaton, Bill Brown, Dale Christine, Neil Bailey, Keith Kunkle, Frank Koch, Warren Bingaman, and assistant coaches Dick Smoker and Steve Jaworek.

Max Leitzel's name can easily be mentioned with those of Bob Shadle, Jack Keller, and Mark Hoffman as the outstanding all-around athletes of their times. A true triple-threat (pass, run, kick) in football, a solid scorer in basketball, and a hard-hitting catcher in baseball, Leitzel took advantage of all the sports Selinsgrove High had to offer at the time. This football pose is from 1951.

Rich Young made Little All-America as quarterback of Susquehanna University's undefeated 1951 team. His passing and total offense records, set during six-game seasons, endured until later expanded schedules. When the five-foot-six-inch 160 pounder asked the New York Giants' Jim Lee Howell for a tryout, the professional coach said, "Try the Redskins." Implied was Washington had five-foot-seven-inch, 165-pound Eddie LeBaron as its quarterback and might be interested in Young. Incidentally, both Young and LeBaron wore jersey No. 14.

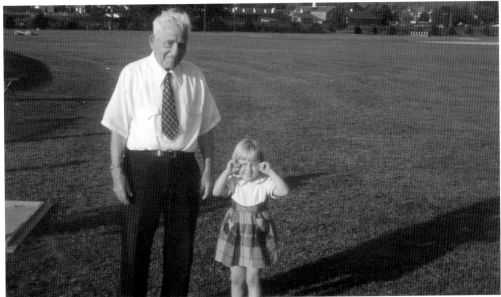

The Grand Old Man of Football, Amos Alonzo Stagg Sr., last coached at Susquehanna University in 1952—at age 90! It was the year that this photograph was taken of the grand old coach and three-year-old Loris Ramer. Like many parents in the county, Jim and Lillian Ramer realized the significance of Stagg's co-coaching the Crusaders with his son, Amos Alonzo Stagg Jr., and wanted a photographic record for posterity.

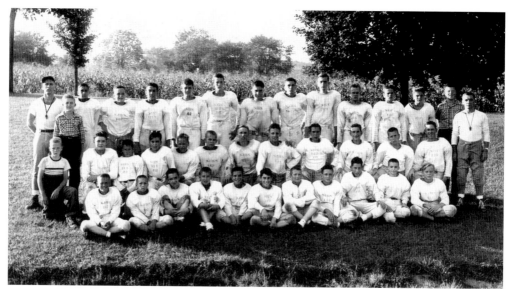

Starting young helps in football. Pictured is the 1952 Selinsgrove Junior High School team. Shown are, from left to right, (first row) ? Ramer, ? Bowen, ? Higgins, ? Troutman, ? Nichols, ? Gaglione, ? Starr, ? Rhoads, R. Ruhl, ? Gaugler, and ? Hendricks; (second row) Ray Benner, ? Wolf, ? Schuck, ? Fox, ? Duncan, ? Gargie, C. Naugle, ? Eichenlaub, ? Slobodian, B. Ruhl, ? Inch, and R. Naugle; (third row) coach Steve Jaworek, ? Shotsberger, ? Smith, ? Heiser, ? Booth, ? Kerstetter, ? Powers, ? Hilbert, ? Hollenbach, ? Mitchell, ? Zerbe, ? Mull, ? Leitner, ? Shadle, and coach Chet Rowe.

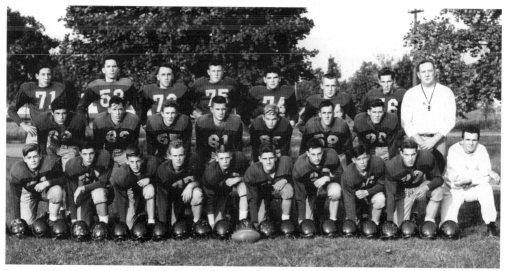

The 1953 Selinsgrove Seals are remembered as "the first team to beat Sunbury." Shown are, from left to right, (first row) Vaughn Wolf, Bob Yerger, Dick Eichenlaub, Al Zerbe, Jim Campbell, Jim Keiser, Don Hane, Len Nichols, Bob Hoover, and head coach Tom Dean; (second row) Barry Hare, Harry Hoffman, Dick Keller, Charlie Hower, Bob Gargie, Jim Gemberling, and Albert Tompkins; (third row) Glenn Bingaman, Mark Hoffman, Bob Trutt, Woody Mengel, Dick Moyer, Carl "Beetle" Bailey, Bob Lewis, and assistant coach Dick Smoker.

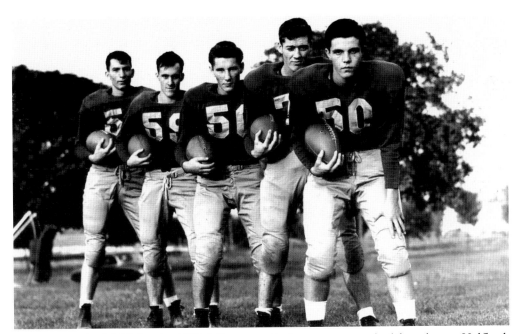

The starting backfield for the 1953 Selinsgrove Seals was composed of five players. Halfback Bob Yerger played on defense while halfback Albert Tompkins played on offense. Fullback Mark Hoffman, halfback Jim Gemberling, and quarterback Bob Lewis played both ways. Shown are, from left to right, Hoffman, Gemberling, Lewis, Tompkins, and Yerger. At 6-4, the Seals represented Selinsgrove High School's first winning team since 1943, and second since 1935. The Bill Scott dynasty was far in the future.

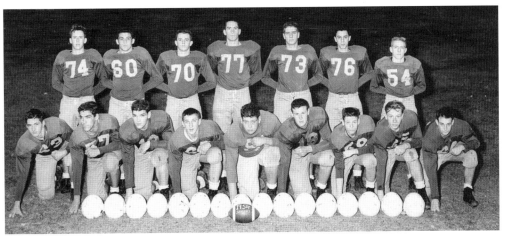

In 1953, coach Tom Dean was greeted by 15 first-day football aspirants. After a winning season, a defeat of Sunbury, and presentation of jackets, there were more seniors the next season than first-day candidates in 1953. Seniors shown are, from left to right, (first row) Mark Reed, Ken Krohn, Dick Moyer, Jim Wittes, Charlie Bickhart, Woody Mengel, Jim Campbell, Ivan Parker, and Don Hane; (second row) George Snyder, Barry Hare, Ron "Rube" Forster, Mark Hoffman, Karl Fahnestock, Johnny Gaglione, and Denny Bowen.

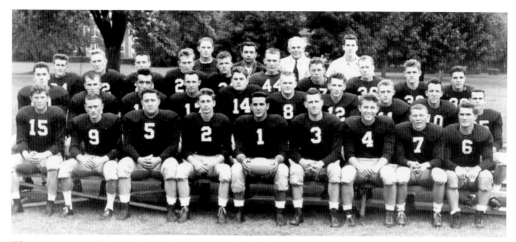

The Stagg era of Susquehanna University football came to an end after the 1954 season. Amos Alonzo Stagg Jr. first came to Susquehanna University in 1935. As co-coach with his famous father, he guided the team to an undefeated season in 1951. On his own, he had led Susquehanna University to an undefeated season in 1940. Several of the 1954 Crusaders were recent Selinsgrove High School graduates. Bob Lewis is shown fourth from the right in the second row. Bob Yerger and Jim Keiser are shown first and second from the right in the third row.

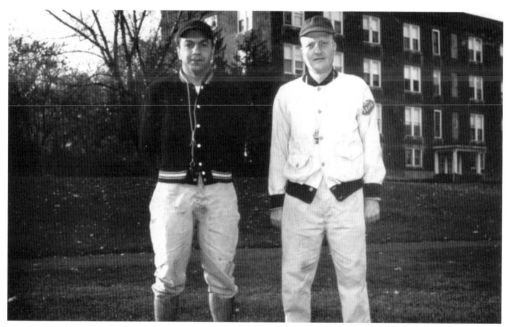

At present, some NFL teams have staffs of 20 coaches. Many big-time college programs have similar numbers. Pictured here is the entire Susquehanna University coaching staff of 1956—head coach Henry "Whitey" Keil (right) and his only assistant, Bob Pittello. Keil was proud of "restoring winning football" to his alma mater from 1955 to 1959. Pittello has coached almost continuously at Susquehanna University since ending his playing career as an undersized, hard-nosed guard in 1950.

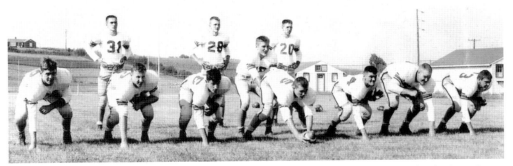

The 1960 Selinsgrove High team was coached by a young John Anderson, who had moderate success with the Seals but went on to win Ivy League championships at Brown University. The starting lineup, from left to right, is linemen Bob Powers, Tim Williams, Eric Reichley, Bob Walker, John Klinger, Rodney "Rock" Keefer, and Bill Wimer, and backs Steve Nace, Ron Wolf, Barry Lewis, and Joe Evers. Anderson took the Seals from 2-7-1 in 1960 to 7-3 in 1962.

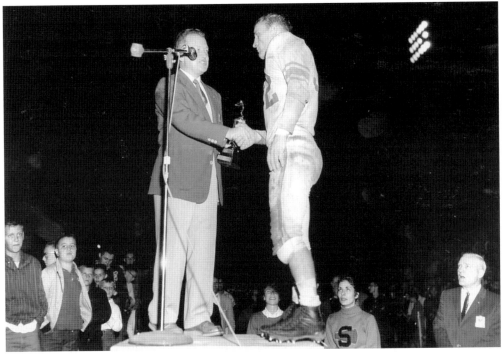

In 1960, under new coach Jim Garrett, Susquehanna University initiated a series of games with rival Lycoming College to play in the Kiwanis Bowl for the Old Hat Trophy. The prize was an old hat of Amos Alonzo Stagg Sr. that star quarterback Rich Young donated. Susquehanna University shut out the Warriors 18-0. Shown is Williamson All-America Ben "Butch" DiFrancesco receiving the Player of the Game Award. Pound-for-pound, "DiFran" is perhaps the finest lineman the Crusaders ever produced. Cheerleader Pat Goetz looks up admiringly.

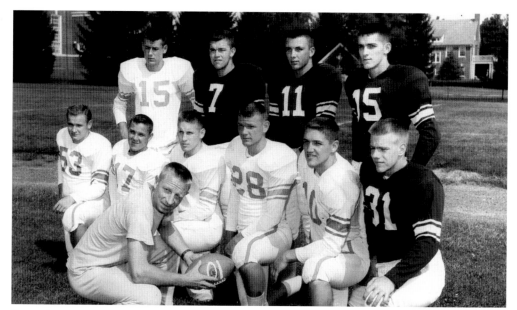

Susquehanna University football has always relied on local talent. Pictured in 1960 with assistant coach Blair Heaton are, from left to right, (first row) Neal "Rhino" Markle (Sunbury), Neal Rebuck (Dornsife), Chuck Bowen (Selinsgrove), John Treon (Sunbury), Stan Jablonski (Northumberland), and Chris Winters (Williamsport); (second row) Barry Hackenberg (Mifflinburg), Larry Kerstetter (Selinsgrove), Terry Kissinger (Selinsgrove), and Rick Bolig (Selinsgrove).

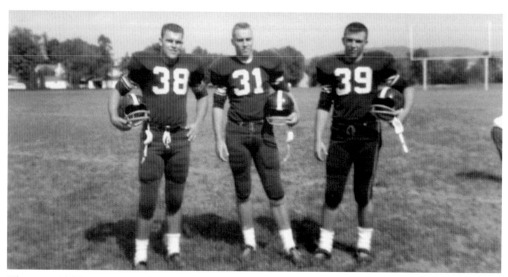

The year 1960 was a watershed year for Susquehanna University football. Jim Garrett arrived and was greeted by a freshmen class that included stellar backfield performers Larry Kerstetter (No. 38), Don Green (No. 31), and Terry Kissinger (No. 39). Green played at Harrisburg's William Penn High School under former Selinsgrove coach Tom Dean. Kissinger and Kerstetter played a Selinsgrove High School for coach Dick Lutrell. All three are in the Susquehanna University Athletic Hall of Fame.

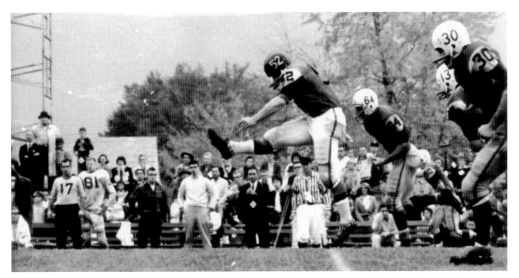

The Jim Garrett years (1960–1965) at Susquehanna University are still referred to as the golden era, boasting a five-year record of 39-4-1. An integral part of the 1962 undefeated season was Tom Samuel, No. 52 (shown kicking off against Lycoming College that year). The closest call the Crusaders had was a 3-0 victory over the Warriors. Samuel, a two-way center in addition to handling kicking duties, lifted the orange and maroon to victory with a late-fourth-quarter field goal of 36 yards for the game's only score.

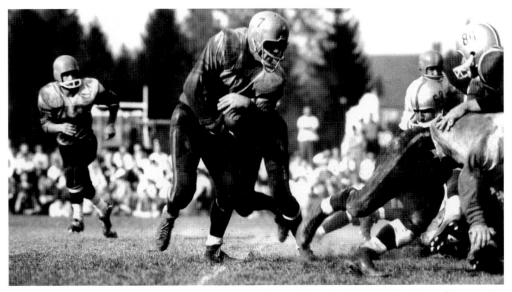

Larry Kerstetter (No. 7) had only two gears—forward and FORWARD! A workhorse, his Susquehanna University jersey was snow white when the game began. The Port Trevorton native could be always counted on for positive yardage. It was not until a late-season game in his senior season, 1963, that he failed to reach the line of scrimmage. He was dropped for a one-yard loss. As a junior, he was an Associated Press All-Pennsylvania first-team choice—the team was chosen from all Pennsylvania football-playing schools.

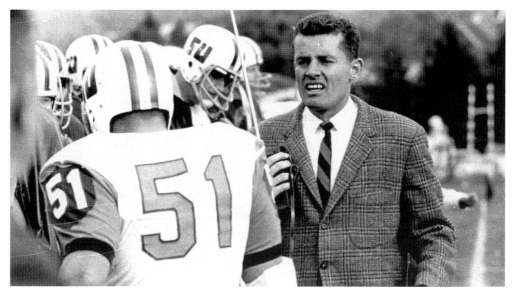

When Jim Garrett (shown in 1964) came to Susquehanna University in 1960, he brought a seldom-matched intensity. He had played college football at St. Mary's College and Utah State University, and in the NFL with the Philadelphia Eagles and New York Giants. He also played in Canada with the British Columbia Lions. In his first five years at Susquehanna University, he compiled a 39-4-1 record, and his team had the longest active winning streak in the nation (22 games) at one time. His greatest victory was a 22-18 upset of Temple University in 1963.

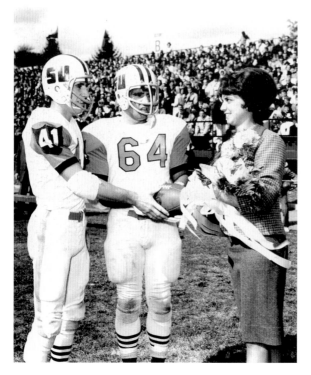

One of the great traditions of Susquehanna football was for the homecoming queen to present the game ball to the Crusaders' cocaptains before kickoff. In 1964, it is lovely Carol Ocker presenting to Larry Erdman (No. 41) and Rich Caruso (No. 64). Erdman's late 77-yard touchdown dash sparked an upset of Temple in 1963. Coach Jim Garrett half jokingly says, "They still show films of that run at the Herndon fire hall on Saturday nights." Herndon is Erdman's hometown. He later signed with the Chicago Bears.

FRIDAY NIGHT LIGHTS AND SATURDAY'S HEROES

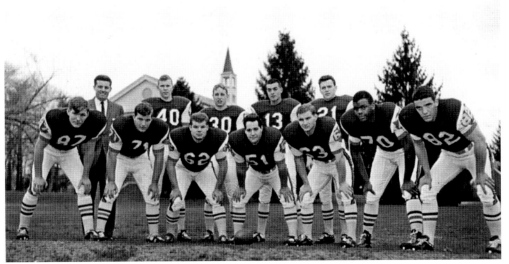

Jim Garrett's last team at Susquehanna University was the 1965 squad. After that, Garrett spent over four decades in the NFL—assistant coach with the New York Giants, New Orleans Saints, and Cleveland Browns. He also had lengthy stints scouting for the Dallas Cowboys. Shown with Garrett is the 1965 starting lineup. Pictured from left to right are (first row) Barry Plitt, Bob Estill, Bill Schmidt, Alex Iacullo, Bill Gagne, Jim Clark, and Garcia Reed; (second row) coach Jim Garrett, Charlie Greenhagen, Greyson Lewis, Nick Lopardo, and Tom Rutishauser.

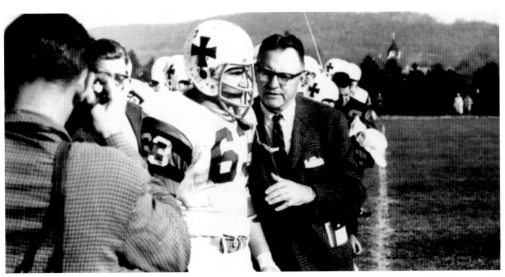

In 1965, after an incident resulted in Jim Garrett's "resignation," Susquehanna University still had two football games to play—and no head coach. President Gus Weber, a fine athlete as an undergraduate at Wagner College, drew national attention when he stepped into the breach. Shown instructing Bill Gagne (No. 63), "coach" Weber breathed new life into a 0-6 program. On this day, the orange and maroon lost a last-minute heartbreaker to Geneva, 29-28, when a two-point conversion play was stuffed.

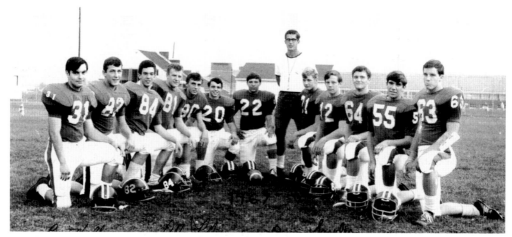

Football coaches will tell people senior leadership is very important. Providing that for Bill Moll's 1967 Selinsgrove High School team, shown from left to right, are Ray Mull, Dave Lawer, Jeff Krouse, Al Harvey, Jim Dreese, Tom Clouser, Doug Snyder, coach Bill Moll, John Newman, Steve Bailey, Steve Davis, Fred Moyer, and Harper Trow. The team was coach Moll's first Seals squad. They were 5-5 and signaled the start of a new winning era for Selinsgrove High School football.

In the late 1960s and early 1970s, Selinsgrove High cheerleaders had much to cheer about. The Seals experienced a resurgence of gridiron good fortune. Huddling against the cold of a 1967 late-season game versus Southern Columbia High School are, from left to right, Brenda Herman, mascot Cara Vignone, Georgia Hendricks, Janie Finn, and Kris Fladmark. The cheering could not generate a victory; Southern Columbia defeated Selinsgrove 20-14.

As important as the players and coaches to overall team success are the student managers. Shown here are those who managed the 1969 Selinsgrove High football squad. From left to right are (first row) Greg Wyatt and Kim Rowe; (second row) Doug Bupp, Eric Rowe, Ronnie Bolig, and Stan Ettinger. They helped the team achieve an 8-2 record, with seven consecutive victories to end the season.

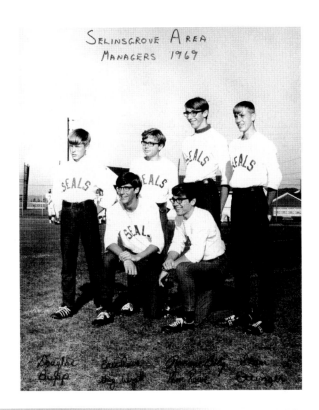

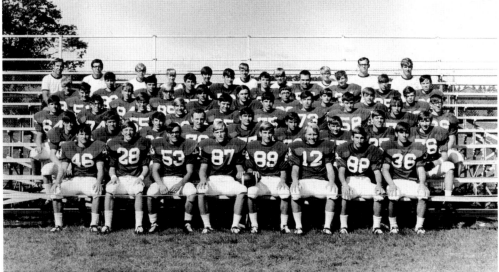

Coach Bill Moll inherited a 1-7-2 team at Selinsgrove High School in 1967 and continued to make marked improvement, going 5-5, 7-3, and 8-2 in his first three seasons. His 1970 Seals finished 9-1, their only blemish a 27-7 loss to nemesis Shikellamy. Headlining the Seals were such stalwarts as cocaptains Stu Reichenbach and Ardie Kissinger, Steve Reichenbach, John Eisenhart, MVP Fred Lenig, and Bob Clouser. Stu won a 9-7 game over Juniata Joint High School with a last-minute, 22-yard field goal.

Steve Freeh of Susquehanna University is a symbol of courage. He lost an arm to cancer as a youngster but continued to play football. In 1969, he won a game (3-0) for the Crusaders with a clutch 40-yard, last-minute field goal versus a vastly superior Westminster team, which was nationally ranked and heavily favored. Coach Jim Hazlett also exhibited courage in allowing Freeh to pursue his dream of kicking at the intercollegiate level. Freeh's career spanned from 1967 to 1970.

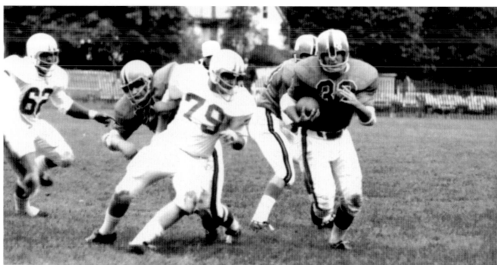

Selinsgrove was a hotbed of football success in 1970. The Seals were 9-1 and the Crusaders 7-3 and champions of the Middle Atlantic Conference (MAC). Coached by former first-team Little All-America center Jim Hazlett, the 1970 Susquehanna University squad featured a strong running game. Supplying the power was fullback Joe Palchak (No. 32, with the ball). Palchak's 1,025 yards stood as the standard for close to 20 seasons and earned him first-team Associated Press All-Pennsylvania—chosen from among all Pennsylvania schools, even Pennsylvania State University!

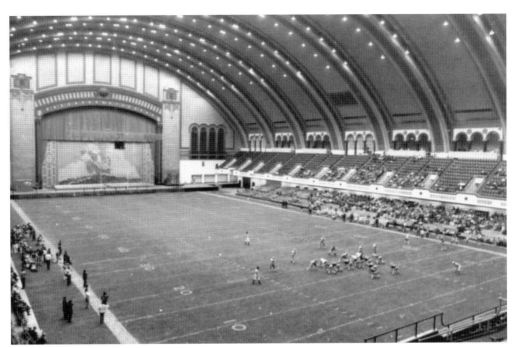

Indoor football is no longer a novelty. Even colleges have domed stadiums. But in 1970, when Susquehanna University played Georgetown University in Atlantic City's Convention Center, the Boardwalk Bowl was indeed noteworthy. Behind Joe Palchak, Ernie Tyler, Jeff Goria, Whitney Gay, Tom Lyons, and Joe Dambrocia, the Crusaders defeated the Hoyas 45-20. The photograph shows the vastness and majesty of the venue, which for years was famous as the site of the annual Miss America Pageant.

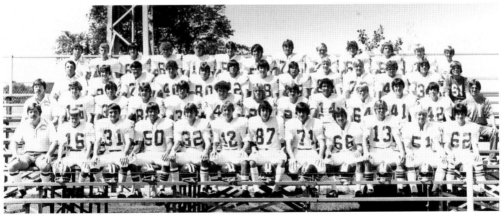

Bill Scott, head coach of the Seals, has given Selinsgrove fans over three decades of winning football. There are those who never thought they would hear the words "perennial power" to describe Selinsgrove High School football, but that is now the case. The 1977 team finished 10-1. Among the leaders of the team were: All-State tight end Gary Nolder, captains Terry Heintzleman, Ron Shaffer, and Keith Stauffer, and Ron Carr, Mike Deckard, Brent Hackenberg, Bruce Heiser, "Fast Eddie" Lockcuff, Ben Reichley, and Rick Schuck.

A 3-3 tie with Lycoming College in the season's opener was the only blemish on Susquehanna University's 1983 record. The Crusaders powered their way to a No. 9 national ranking in Division III football and an MAC title. Fullback Hank Belcolle was MAC Most Valuable Player and Eastern College Athletic Conference (ECAC) Player of the Year. Tom Bariglio, Andy Foster, Earl Fullerton, Rod Bamford, Dennis Dyroff, George Stockberger, Steve Miller, and Roy O'Neill joined him on the All-MAC team. Bill Moll was a Kodak Coach of the Year.

Smallish players have carried the red and blue colors of Selinsgrove High School on the football field over the years, but it is doubtful if anyone suited up for the Seals who was smaller than Russell "Rusty" Baker in the 1980s. Baker, by his senior year, was five foot two inches and 85 pounds. That's right—eight-five! He remembers, "Coach [Mark] Bricker offered me a pizza if I ever topped 100 pounds." But, like Chet Rowe and other diminutive Seals, Baker proved that sometimes athletic ability comes in "the convenient 'travel size' package."

"Get Your Kicks . . ."

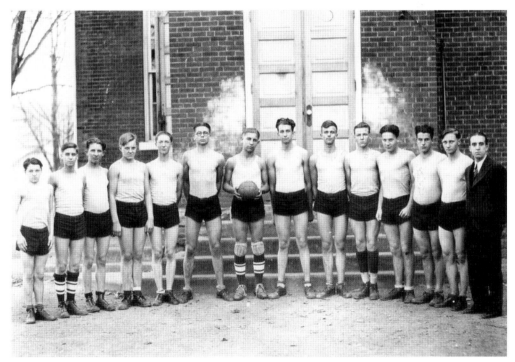

Freeburg High School fielded a boys' soccer team about a year after the sport was introduced to the county by Middleburg and Beaver Vocational High Schools. This is that first Freeburg High School Bears team, which began play in 1930. Prof. Eugene Stoudt served as the first coach. Shown are, from left to right, Stewart Mengel, Elmer Boyer, Ray Heintzelman, Lon Aucker, Myron Lenig, Bob Kissinger, Gene Broscious, Charles Fisher, George Walborn, Gene Walter, Paul Roush, Harvey Gaugler, Charles Glass, and coach Eugene Stoudt.

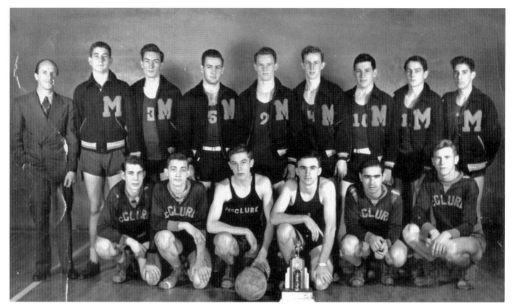

McClure High School was another Snyder County school that offered soccer long before the soccer boom of the 1970s. The 1947 team proudly poses with a recently won trophy. Shown are, from left to right, (first row) Donald Baker, David Kline, Fern Goss, Jay Ferguson, Ed Wagner, and Clair Wagner; (second row) coach Joseph Dodd, John Bilger, Rudy Wagner, Nelson Kline, Ellsworth "Slug" Dean, Jack Knepp, Richard Conner, Richard Klingler, and Jack Morgan.

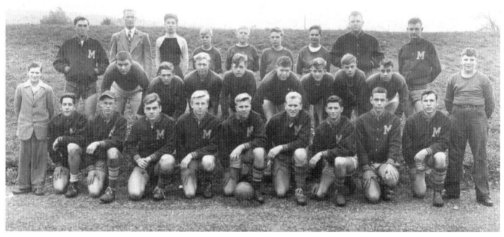

The 1950 Middleburg High School soccer team was crowned champion of the Snyder County League. Shown are, from left to right, (first row) L. Hestor, D. Johnson, R. Feltman, G. Hall, G. Hall, captain J. Hestor, P. Bowersox, L. Nornhold, H. Walter, M. Inch, and B. Hestor; (second row) D. Hackenberg, A. Good, D. Hackenberg, S. Osgood, J. Clark, J. Runkle, R. Knouse, M. Arbogast, F. Steimling, and B. Sharadin. The third row includes coach C. Zimmerman, B. Bateman, H. Lesher, W. Runkle, R. Kuhns, B. Walter, and R. Fensterbush.

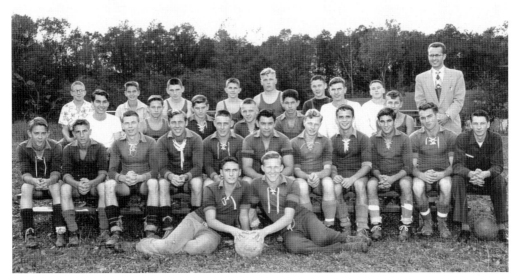

After college (Bloomsburg University), Norman Kline returned to teach and coach at his alma mater—McClure High. The 1954 Trojans are shown here, from left to right, (first row) N. Boonie and J. Heeter; (second row) G. Wagner, T. Loudenslager, D. Snook, G. Berryman, R. Stringer, J. Folk, J. Reitz, J. Weader, B. Morgan, P. Hockenbrock, and P. Musser; (third row) H. Romig, C. Shawver, R. Ward, J. Wagner, G. Crawford, R Albert, and H. Oberlin; (fourth row) J. Kline, R. Boonie, S. Kline, M. Yost, N. Gilbert, D. Ewing, C. Kline, and coach Norman Kline.

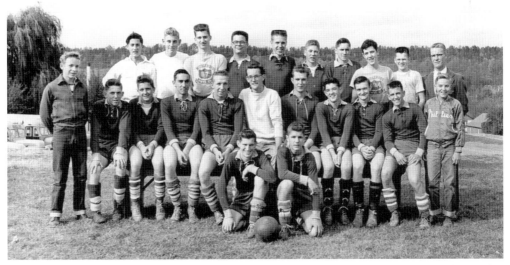

Middleburg High's 1956 soccer team was a determined group. Shown are, from left to right, (first row) Lenus "Peanut" Hestor and Mike Hermann; (second row) manager Chester Hoffman, Larry Walter, Ron Wenrich, Larry Loss, Len Kuhns, Harry Powers, Rich Kerlin, Gary Gill, Luther Yetter, Dick Bilger, and manager Jim Lesher; (third row) Gary Heim, Dave Herbster, Larry Hummel, Jack Hoffman, Aldis Klavins, Roger Mitchell, Clair Bowersox, Ted Whitesel, Dale Bingaman, and coach Charles Zimmerman.

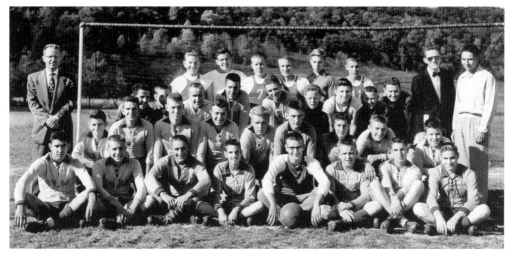

Several "booters" on the 1954 McClure High soccer team were members of the first West Snyder High School team in 1956. Shown are ? Crawford, ? Goss, ? Stringer, ? Boonie, ? Arnold, J. Wagner, ? Loudenslager, ? Haines, ? Baker, ? Yost, ? Thomas, ? Oberlin, ? Gilbert, ? Kline, ? Fetterolf, ? Lingle, ? Troup, ? Weaver, ? Riegle, ? Knepp, ? Romig, ? Will, ? Spaide, ? Hackenberg, ? Hawk, ? Benner, coach Norman Kline, D. Kratzer, ? Bickhart, ? Renninger, ? Flood, H. Kratzer, ? Pheasant, and ? Dippery.

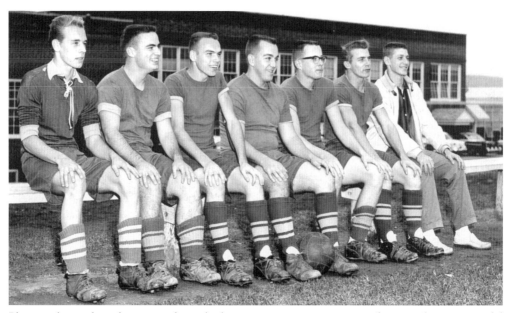

Players who stick with a sport through their senior season are integral parts of any successful team. Seniors on the 1961 Middleburg Middies are, from left to right, Marvin Walter, Dan "Duke" Travelet, Dave Kratzer, Richard Herbster, Paul Fletcher, Richard "Buddy" Bickhart, and manager John Steininger. Absent from the photograph is Don Brubaker. Travelet starred at Susquehanna University, setting goal-scoring records, and is a member of the Susquehanna University Athletic Hall of Fame.

"GET YOUR KICKS . . ."

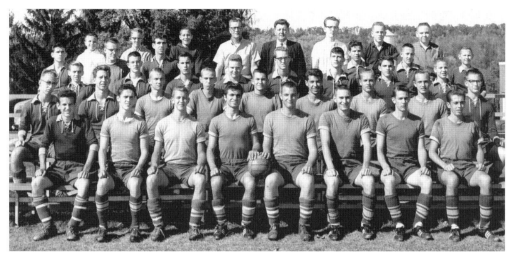

By 1963, soccer was well established at Middleburg High School. Shown from left to right are (first row) ? Weaver, ? Hassinger, ? Heintzelman, ? Inch, ? Savidge, ? Simington, ? Shaffer, and ? McClellan; (second row) ? Walter, ? Ernest, ? Erb, ? Steininger, ? Goodling, ? Shaffer, ? Reitz, ? Savidge, and ? Goodling; (third row) ? Shaffer, ? Hackenberg, ? Sprenkle, ? Loss, ? Walter, ? Hummel, ? Shaffer, and ? Fisher; (fourth row) ? Lytle, ? Walter, ? Aurand, ? Weaver, ? Musser, and ? Swinehart; (fifth row) ? Strocko, ? Zimmerman, ? Steffen, coach Charles Zimmerman, coach Felker, ? Aucker, ? Snook, and ? Yetter.

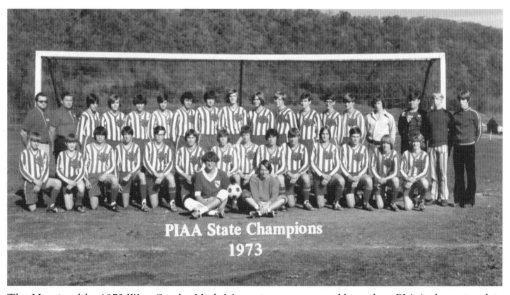

The *Hoosiers*-like 1973 West Snyder High Mounties soccer squad brought a PIAA championship to Snyder County. Shown are, from left to right, (first row) ? Schmidt and ? Mattern; (second row) ? Edmiston, N. Tyson, ? Haines, ? Fogel, ? Lepley, ? Middleswarth, ? Moser, ? Dean, J. Knepp, ? Moyer, ? Erb, A. Tyson, ? Goss, and ? Everly; (third row) assistant coach Jerry Botdorf, head coach Raymond Moyer, R. Wagner, ? Rigel, ? Byler, S. Knepp, ? Aikey, ? Bowersox, ? Hassinger, ? Guyer, ? Yetter, ? Wray, ? Wert, B. Wagner, ? Krick, and managers Moyle, Baker, and Snyder.

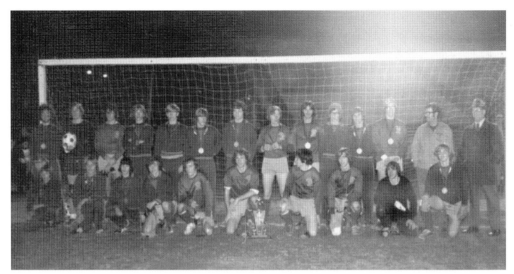

Not to be outdone by West Snyder High School, Middleburg High School won a state championship in 1974. Coached by Jim Aurand, the Middies won in a comeback thriller—5-4 over Bethlehem Freedom High School. The squad is shown after that victory. Players include (not in order) ? Stewart, ? Lupolt, ? Courtney, ? Goodling, C. Bingaman, ? Brouse, ? Stock, ? Bolig, ? Sheaffer, ? Snyder, ? Millhouse, ? Shellenberger, ? Swinehart, ? Attig, ? Roush, ? Garman, ? Zechman, ? Franchina, ? Landis, ? Predix, B. Bingaman, ? Felker, ? Hoffman, ? Lauver, ? Kerstetter, and ? Stetler.

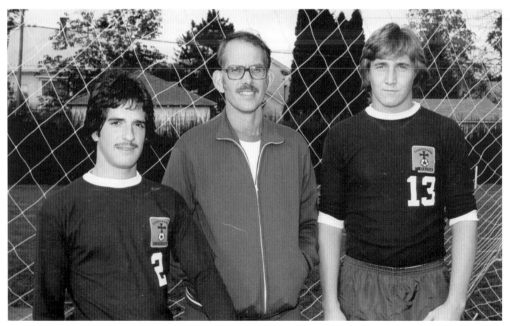

In the fall of 1977, Susquehanna University soccer recorded what the *Lanthorn* called "perhaps the best season ever." The seven victories of a 7-4-2 record represented the most ever by a Crusaders squad. The team, coached by Dr. Neal Potter, was paced by cocaptains Tom Cook (left) and Howard Baker, flanking coach Potter.

"GET YOUR KICKS . . ."

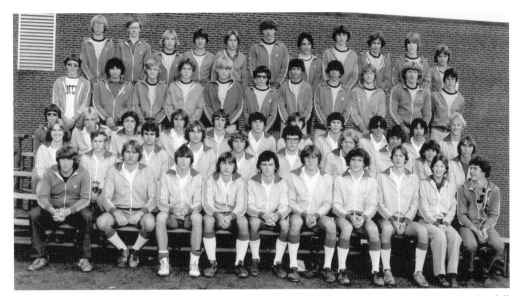

Head coach Jim Aurand and assistant Steve Steffen turned out a fine soccer team in the fall of 1978 at Middleburg. The Middies were 11-2 in the Tri-Valley League (TVL) and 17-5 overall. They lost a 3-2 thriller to archrival West Snyder in the District 4 championship, then lost another playoff game to eventual state champion Fleetwood High School. Chris Lupolt, a center midfielder was team MVP. Lupolt, David Goodling, Scott Predix, Greg Klose, and Brad Dressler earned All-TVL honors. Shown are the varsity and junior varsity squads.

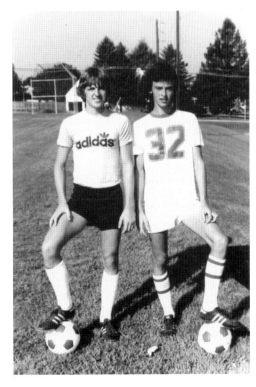

With no football team, Middleburg High was a soccer school of long standing. Coach Carl E. Slaybaugh began the program in 1929. By winning the 1930, 1932, and 1942 unofficial state championship, the Middies retired the Jeffery Cup—instituted by longtime Penn State soccer coach Bill Jeffery. For years, the Snyder County League was about the state's only soccer conference. Shown are the Middies' 1978 cocaptains Mike Gill (left) and Chris Lupolt.

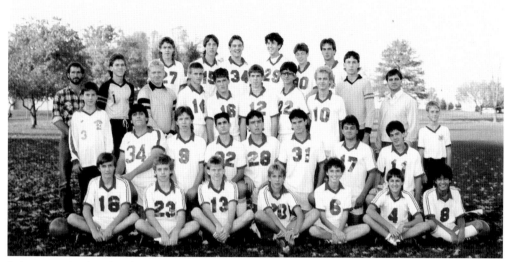

Selinsgrove High School made soccer a varsity sport in 1985. Shown are, from left to right, (first row) D. Cumberland, C. Cottrell, J. Reichenbach, A. Lauver, T. Schuck, M. Campbell, and S. Bilger; (second row) P. Heintzelman, J. Moran, E. Dawson, C. Praul, D. Hoke, J. Handlan, C. Keister, K. Spigelmyer, and J. Steffen; (third row) assistant coach Jeff Kerstetter, D. Herrold, T. Kratzer, J. Temple, J. Fischer, S. Wiley, B. Potter, J. Leitzel, S. Troutman, and head coach Steve Steffen; (fourth row) D. Fincke, R. Hanson, G. Hoke, M. Kiffman, D. Brumback, and J. Schriver.

With strong support from Dr. Neal Potter, Dr. Karl Rohrbach, and Dr. John Pagana, Steve Steffen instituted soccer as a club sport at Selinsgrove High School in 1984. Extremely successful, Steffen won 273 games, seven District 4 titles, and advanced to the PIAA state quarter-finals four times. As a tribute to the late coach, the Coach Steve Steffen Memorial Soccer Field and memory garden were dedicated in his name on May 6, 2006. As great a coach as Steve Steffen was—and he was a great one—he was a better person.

"GET YOUR KICKS . . ."

HOOPIN' IT UP

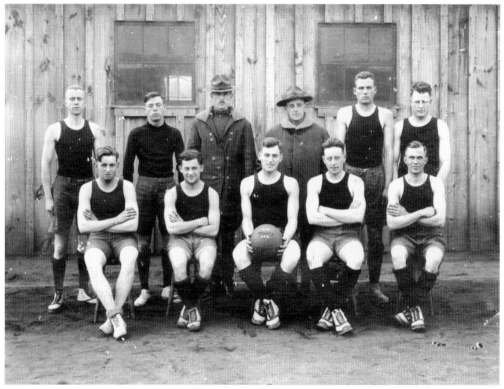

Like many of his generation, Everett "Cuffy" Bolig served in World War I. While training at Camp Alfred Vail in Little Silver, New Jersey, the athletically talented Selinsgrove resident found time to play on the camp basketball team in 1918. Bolig occupies the spot reserved for the team captain—front row, center, holding the leather-laced ball. The team appears to be coached by an officer and an enlisted man—in U.S. Army uniforms rather than hoops uniforms. Bolig later enrolled at Susquehanna University.

There were two versions of Selinsgrove's Keystone Club basketball team during the 1919–1920 season. The other was published in Images of America: *Snyder County*. This photograph is missing mainstays Pete Youngman and Harold Follmer but features Cuffy Bolig, Ken Moyer, Al Seiler (back row, second, third, and fourth from the left,) and Bruce Wagenseller (seated, extreme right). Research failed to identify the first two players (from left to right) in the front row or the first man (left) in the back row.

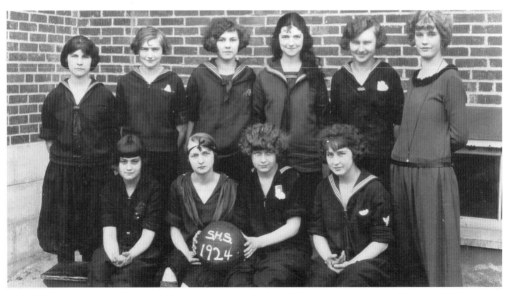

Basketball was about the first sport schools and colleges offered to girls and women. The Selinsgrove High School team of 1924–1925 poses proudly in its fashionable middies. The girls played to a 7-2 record. Many of the scores were in the low double digits—some even in single digits. Shown are, from left to right, (first row) Medora Coldren, Mary Whitely, Agnes Coldren, and Alberta Renner; (second row) Mary Wentzel, Lena Wenrich, Eva Lieby, Cathryn Wagenseller, Margaret Boyer, and manager Elva Hare.

HOOPIN' IT UP

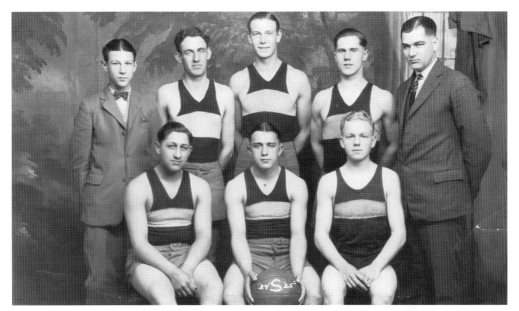

Selinsgrove hoopsters had no gymnasium of their own at this time (1924–1925) but played at Susquehanna University's old Alumni Gym. This studio photograph shows, from left to right, (first row) guard Bob Wendt, captain and forward Clarence Updegrove, and guard Reno Knouse; (second row) manager Arnold Michaels, forward Elmer Haines, center George "Jack" Spaid, forward Bill Ulrich, and coach Ken Moyer. Moyer was a member of earlier Keystone Club basketball teams. Absent from photograph is guard Charles Marks.

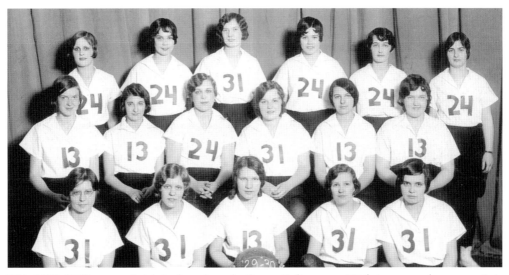

This 1929–1930 group of girls is thought to be from a Selinsgrove High intramural program. It is unique in several ways. Only three different numbers are used—31, 13, and 24—by the 17 girls, and a close look reveals the numerals are probably cut from construction paper and pinned to the girls' blouses. The only positively identified player is Edith Boyer, who appears in the back row on the extreme right.

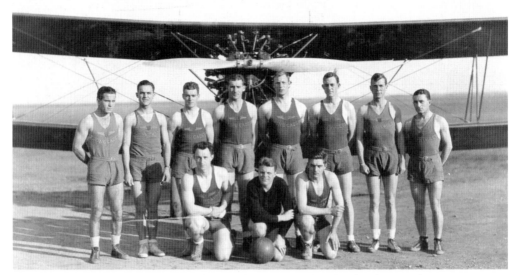

With the persistent help of Harold Follmer, Selinsgrove High School and Susquehanna University graduate George "Jack" Spaid was accepted into the U.S. Army Air Corps. Spaid took his flight training at Kelly Field in Texas in 1930. He is pictured (back row, fourth from the right) with his base basketball teammates in front of a wooden-prop biplane trainer. One teammate is Christy Mathewson Jr. (kneeling, extreme right), the son of immortal Bucknell University and New York Giants hall of fame pitcher.

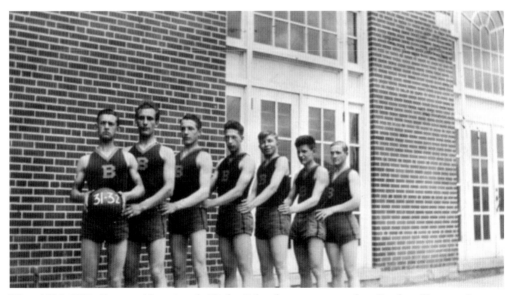

The 1930–1931 Beaver Vocational High School team won the Snyder County League championship with a 16-4 record. Shown are, from left to right, Bill Walter, Parke Herbster, James "Sonny" Herman, Fred Mattern, Ray Kline, Carson Gill, and Marlin Haines. Frank Gill coached the Beavers. Ninety-year-old Ray Kline, the only surviving member, says, "There were more players, but we only had seven uniforms, so that's all who got in the picture."

HOOPIN' IT UP

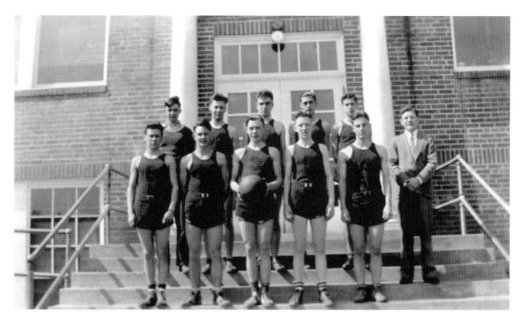

A star athlete himself, Sherman Good returned to the west end of Snyder County after graduating from Susquehanna University to teach and coach at McClure High School. The 1933–1934 team is shown here. From left to right are (first row) Donald Felker, Claude Hawk, Dallas Brininger, Donald Wertz, Carl Boonie, and coach Sherman Good; (second row) Spurgeon Edmiston, Carmon Renninger, Seal Fleming, Glen Arnold, and Robert Felker.

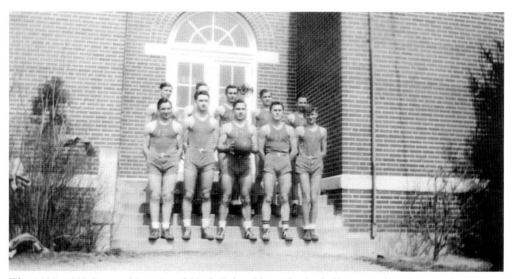

The 1938–1939 Beaver Vocational High School boys' basketball team is lined up on the steps of the school for a squad photograph. They were winners of the Snyder County League championship that year. Shown are, from left to right, (first row) Harry Hartman, Donald Klinepeter, Dick Eisenhauer, Wilmer Grimm, and Andrew Bingaman; (second row) Bob Middleswarth, Bob Edmiston, Joe Treastor, Bob Thomas, and Fred Krebs. Note several discarded warm-up jackets hanging in the shrubbery at the left of the photograph.

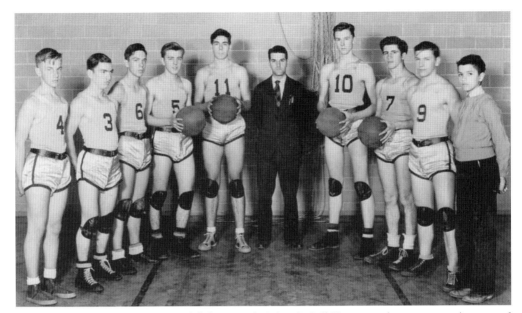

Like others in Snyder County, Middleburg High School's Bill Hermann (center, in suit) returned to his high school alma mater to teach and coach after graduation from Susquehanna University. This is the Middies' 1942–1943 team. Shown are, from left to right, Robert "Satch" Bilger, Walter Travelet, Jack Bachman, Richard Felker, Arthur Erb, coach Bill Hermann, John Grimm, Stan Houser, Elmer Ernest, and manager Jim Hill. Note the leather knee pads.

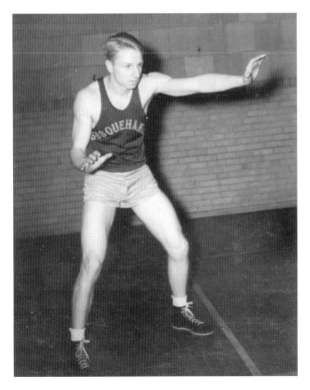

Blair Heaton, shown in 1942 at Susquehanna University, was a skilled basketball player—as well as a star in other sports, namely football and track and field. With his friend and fellow gridder Phil Templin, Heaton made the orange and maroon a force to reckon with. He is considered by many to be the university's finest all-around athlete. Heaton later coached basketball, football, and golf at Selinsgrove High School.

HOOPIN' IT UP

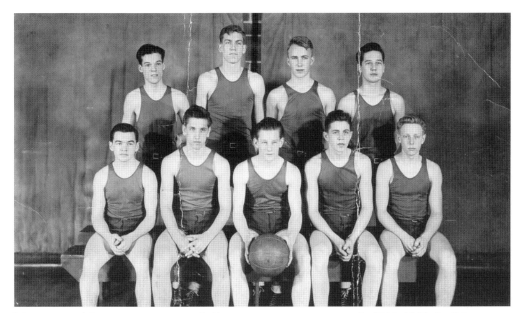

Most successful varsity programs are fed by a junior varsity program. In 1944–1945, the Selinsgrove High junior varsity supported the varsity quite well. Shown are, from left to right, (first row) Ellie Rowe, Carl Dressler, Glenn Shaffer, Dick Bogar, and Amos Alonzo Stagg III; (second row) Lee Herman, Herb Schultz, Don Fisher, and Bob Kuster.

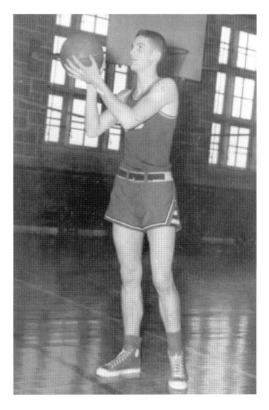

Jack Keller (shown)—with substantial help from Selinsgrove High mates such as Tommy Slayback, Bill Rowe, Ned Long, Ronnie Day, Dick Kretz, Marvin Bonawitz, Johnny Robinson, Rupe Leohner, Ken Fahnestock, and Marty Hughes—led the 1949–1950 Seals to a Susquehanna Valley League championship. The squad was, perhaps, the best Selinsgrove High School basketball team of the era.

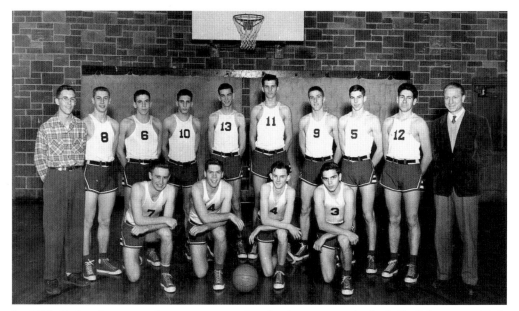

In 1950–1951, when a six footer was considered a big man in basketball, Selinsgrove High School had the luxury of six-foot-eight-inch Bob Ortmyer (No. 11). Ortmyer went on to set long-standing rebounding records at North Carolina's Lenior-Rhyne College. Shown are, from left to right, (first row) Roger Hepner, Ned Long, Glenn Hane, and Bill Adams; (second row) manager Charlie Hummel, Dick Kretz, Max Leitzel, Bill Rowe, Rich Bilger, Bob Ortmyer, Galen Campbell, Jerry Soper, Jim Hill, and coach Blair Heaton.

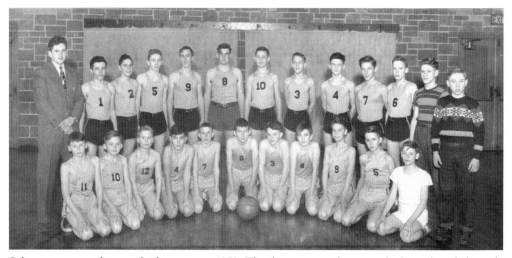

Selinsgrove started junior high teams in 1950. The front row is the seventh through eighth-grade team; the back row is the ninth-grade team. Shown are, from left to right, (first row) Ray Morris, Gene Shotsberger, Jerry Rhoads, Dean Booth, Charlie Roush, Barry "Buzz" Siegfried, Ron "Rube" Forster, Bob Rau, Allen Rowe, George Snyder, and Jim Campbell; (second row) coach Ken Borst, Bob Yerger, Ronnie Slayback, Dick Keller, Jim Gemberling, Bill Kissinger, twins Ken and John Shillingsford, Gerry Herbster, Bob Lewis, Ed Rhoads, and managers Jim Keiser and Carson Naugle.

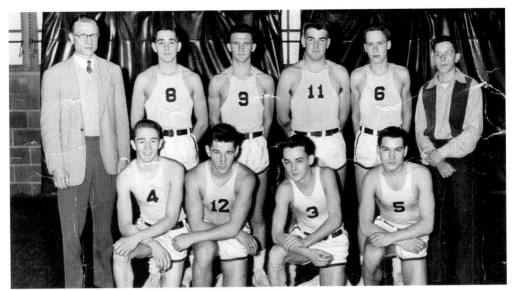

Just a couple of seasons removed from a Susquehanna Valley League championship, this is the 1952–1953 Selinsgrove High team. Shown are, from left to right, (first row) Dick Keller, Bob Lewis, Nelson Bailey, and Tom Aungst; (second row) coach Blair Heaton, Neil Bailey, Gerry Herbster, Bill Kissinger, Ed Rhoads, and manager Warren "General" Walborn.

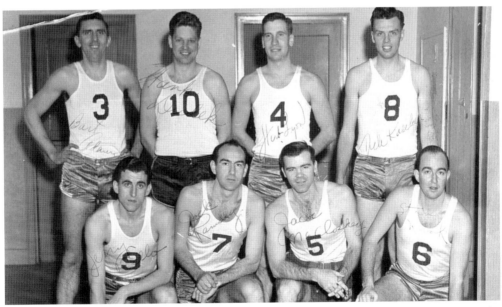

Many county sports fans made the Sunbury Mercuries' games a Saturday night ritual (from the 1940s through the 1970s) This team from the "Mercs" heyday of the 1950s features, from left to right, (first row) Jerry Rullo, "Dr. Jack" Ramsey, Jack McCloskey, and coach Stan Novak; (second row) Bart Adams, Hank Dudek, Herb Lyon, and Dick Koecher. Ramsey and McCloskey made their marks in the NBA. Ramsey led the Portland Trailblazers to an NBA title; McCloskey was general manager of the Detroit Pistons during their "Bad Boys" reign.

The shiny hardwood floor of "the friendly confines" of Selinsgrove High School's gymnasium gives away the setting of this photograph. Proudly displaying the varsity S is the cheerleading squad of the 1952–1953 basketball season. Shown are, from left to right, junior Joy Metzger, sophomore Diane Miller, senior cocaptain Jackie Brungart, senior cocaptain Esther Wimer, junior Joan Yohn, and sophomore Roberta Swank.

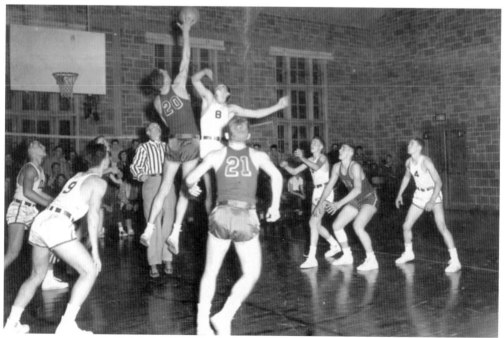

Somewhat of a rarity now, but not then, is a jump ball. During the 1952–1953 season, in a game between Danville High School and Selinsgrove High, Neil Bailey (No. 8 in white) goes up against a taller Ironmen opponent. Other Seals are, from left to right, Bob Lewis (No. 12), Gerry Herbster (No. 9), Ed Rhoads (No. 6, obscured), and Dick Keller (No. 4).

HOOPIN' IT UP

The Beavers of Beaver Vocational High School competed in the Snyder County League, but 1953 was a rebuilding year for the purple and gold. They once "froze" the ball to keep Freeburg High School—led by Donnie and Glenn Moyer—from reaching 100 points. They were coached by Marlin Shearer. Shown are, from left to right, (first row) Lew Ettinger, Ivan Peters, Leon Bickhart, Erman Lepley, and Jack Kauffman; (second row) Wayne Herman, Don Hockenbrock, Leon Earl Fetterolf, and Tuck Archibald.

Posing with warm-ups—something new—over their uniforms, the 1953–1954 Selinsgrove Seals are not exactly smiling for the camera. Shown are, from left to right, (first row) Jim Wittes, Bob Lewis, Dick Keller, Bob Yerger, George Snyder, and Jim Keiser; (second row) Mark Hoffman, Barry "Buzz" Siegfried, Ron "Rube" Forster, manager Jim Snyder, coach Blair Heaton, manager Johnny Baskin, Gerry Herbster, Ed Rhoads, and Bill Kissinger. Missing from the photograph is Dave Davis.

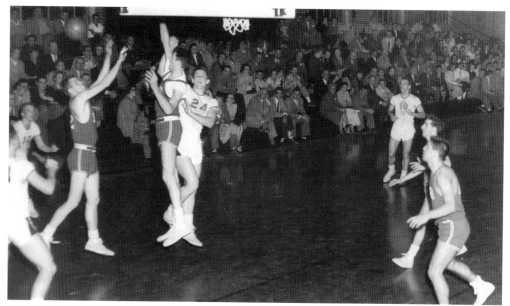

Selinsgrove's Jack Keller's main contribution to the Gettysburg College team was sweeping the backboards for rebounds. In this action shot against Dickinson College during the 1953–1954 season, Keller (No. 24 in the middle of the photograph) is mixing it up under the boards. When Keller and the Bullets played at Bucknell University, a large local contingent helped to fill Bucknell's Davis Gym. After college and minor-league baseball, Keller played baseball for U.S. Marines service teams at Quantico and Camp Lejeune and also in Hawaii.

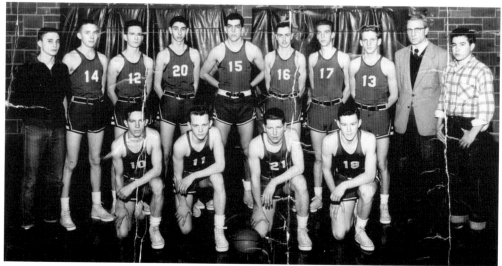

Blair Heaton continued his tenure with the Selinsgrove High School basketball team. This is the 1955–1956 version of the Seals. Shown are, from left to right, (first row) Len Nichols, Jim Hendricks, Sam Leitner, and Larry Troxell; (second row) manager Tom Helvig, Gene Shotsberger, Neal Rhoads, Don Bingaman, Dean Booth, Clyde Herman, Allen Rowe, Dick Eichenlaub, coach Blair Heaton, and manager Larry Fox.

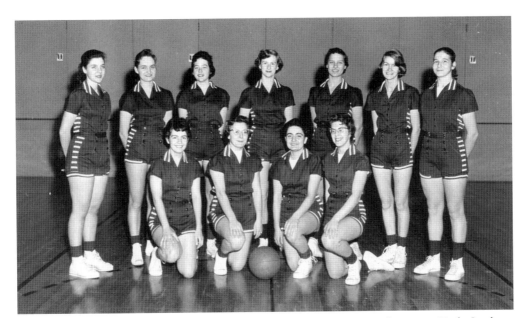

Girls' basketball was a well-established program by the mid-1950s at Selinsgrove High. In those days, it was still a half-court game played with six on a side. Guards could not cross the center-court line; forwards were the only ones who could shoot and score. There was no center, as such. Shown is the 1956–1957 squad. From left to right are (first row) Toni Ranck, Ruth Ann Teats, Barb Boyer, and Julie Kerstetter; (second row) Barb Smith, Pat Brouse, Mary Lou Williams, Diane Wind, Ann Rowe, Sandra Graham, and Ruth Ann Yoder.

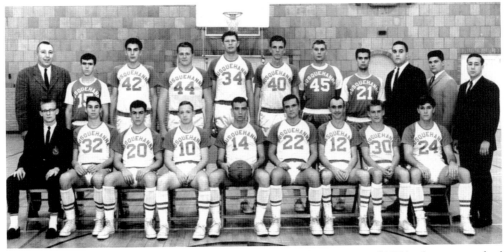

During the 1950s and 1960s, John Barr—a Penn State All-America and NBA player—coached the Susquehanna University Crusaders. This is the 1964–1965 squad. Shown are, from left to right, (first row) manager Bill Pearce, Paul Wilde, Bob Chandler, Tom Endres, Joe Billig, Bob Hancock, Billy O'Brien, Nick Dunn, and Barry King; (second row) coach Barr, Dean Kennedy, Otto "Butch" Uguccioni, Clark "Duke" Schenck, Tom McCarrick, Bob Good, Jim Zimmerman, Rich Politi, and managers John Clapham, Bob Dunham, and Alan Krichev.

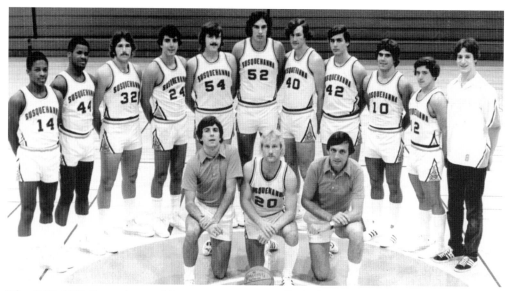

The 1977–1978 Susquehanna University team was called "the second-best in SU history." The squad posted a 15-10 mark and was paced by five-foot-eight-inch Mike Schieb, who was voted "the outstanding under-six-feet player in the nation." Shown are, from left to right, (first row) assistant coach Jim Baglin, captain Mike Schieb, and head coach Don Harnum; (second row) Rodney Brooks, Charles Ferguson, Larry Weil, Charles Lorenzo, Bruce Gessner, Bruce Bishop, Jim Gladwin, Mark Sacco, Randy Westrol, John Davis, and Jeff Lesser.

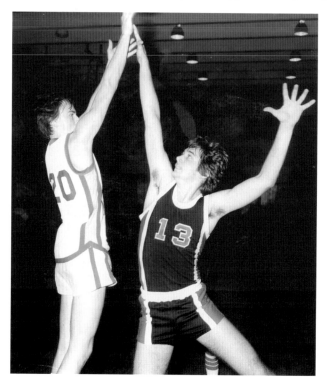

Chris Lupolt was as skilled and versatile as the best athletes to wear the blue and gold of Middleburg High School. Shown shooting (No. 20), he was the team's leading scorer and amassed "about 700 points" during his hardwood career. His finest year was 1977–1978 when he was MVP in soccer, basketball, and baseball. He matriculated at Susquehanna University and played soccer for Jim Aurand and Steve Steffen. He assisted the late coach Steffen for a decade before taking over Selinsgrove boys' soccer in 2005.

GRAPPLING WITH SUCCESS

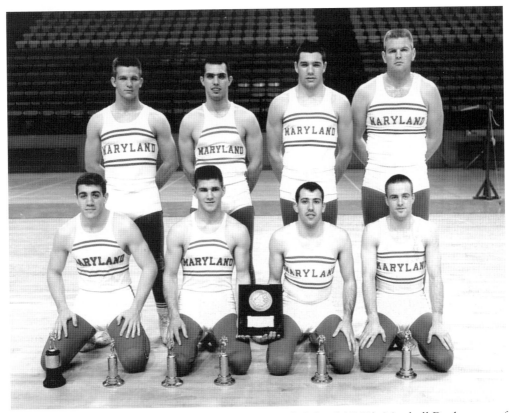

In just the fourth year of wrestling at Selinsgrove High School (1960), Marshall Dauberman of Kratzerville won the PIAA championship at 180 pounds. This earned him a scholarship to the University of Maryland, where he was Atlantic Coast Conference (ACC) champion for three years (1962–1964) and an All-American. He is shown (back row, second from the right) with the seven other Terps who won ACC championships. If the blond heavyweight (back row, extreme right) looks familiar, it is because he is Roger Shoals, who played offensive tackle for nine years in the NFL.

In 1964–1965, Middleburg High School head coach Stan Nolan and assistant coach Bill Burns began a wrestling program. Shown are, from left to right, (first row) managers Ron Kratzer and Jim Hackenberg, Tom Rice, Jerry Fisher, Clifford Loss, Richard Nace, Mike Kratzer, Greg Felker, Larry Lytle, Carey Sheaffer, and Tom Hughes; (second row) coach Stan Nolan, Daryl Zechman, Dennis Hackenberg, Dave Kline, Joe Fopeano, Joe Walter, Tom Mitchell, Larry Walter, Eric Stahl, Carl Landis, Bob Brobeck, and coach Bill Burns.

The 1965–1966 University of Maryland freshman wrestling team was undefeated—9-0. The grapplers had a Snyder County flavor. In the front row, second from the left, is Gobel Kline of West Snyder High School—eyes closed, perhaps dreaming of the 1969 NCAA national championship he would win. Bob Walker, a fine wrestler at Selinsgrove High School who did a stint in the U.S. Marine Corps before matriculating, is in the back row, third from the left. Like the team, Kline was undefeated. He also won the Freshmen Easterns.

GRAPPLING WITH SUCCESS

Walt "Bowie" Van Nuys (shown in 1967) was a solid lightweight wrestler at Selinsgrove High when Dick Smoker initiated the program. An above-average grappler for the red and blue, he spent a year at Susquehanna University before transferring to the University of Maryland, where he became part of the Terps' squads that dominated the ACC in the late 1960s.

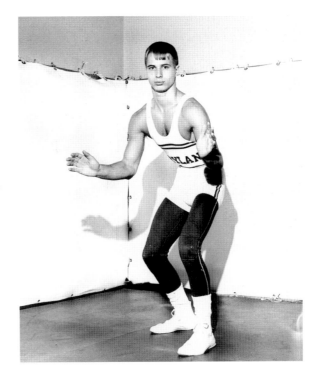

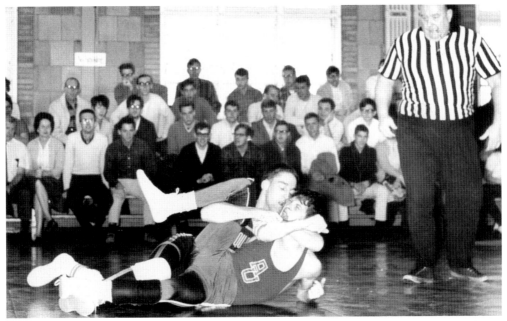

In the late 1960s, Lamar Knight (rear) was a marvel at Susquehanna University. He is shown about to make an American University opponent say "uncle!" On Saturday afternoons, the question circulated at Selinsgrove's Bot's Café was, "Are you goin' out to SU to see Lamar pin his man?" They went; he did. The rather imposing referee is successful Selinsgrove High coach Dick Smoker.

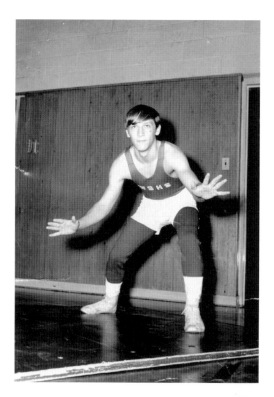

With an overall career record of 89-5 at West Snyder High School, Ken Hess is considered one of Snyder County's all-time best. A four-time District 4 champion—twice at 95 pounds, then at 103 and 112—he placed second in the PIAA tournament as a sophomore. He won gold at state as a junior in 1968, on his way to a 25-0 record. He was upset as a senior in the regionals. Alan Goss was an earlier West Snyder state champion—in 1964 at 120 pounds.

Former West Snyder High Mountie Gobel Kline has every reason in the world to be beaming. He is exhibiting his award as the 1969 NCAA 152-pound national champion. In 1968, like Marshall Dauberman, Kline earned All-America honors by placing fourth in the nation. Kline, again like Dauberman, was a three-time ACC champ. Kline and Dauberman are further linked by recently being named to the All-Time ACC 50th anniversary team.

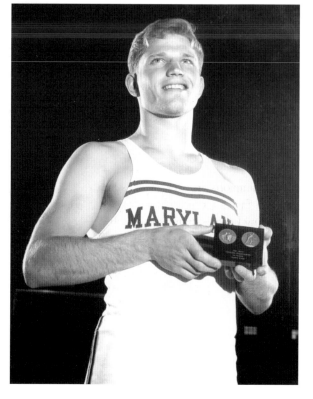

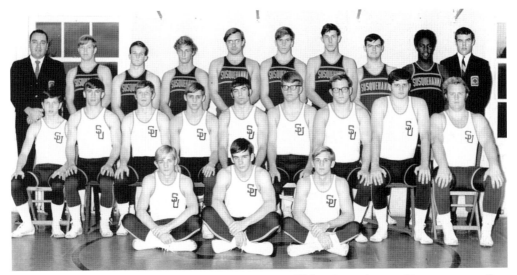

Coach Charlie Kunes was drawing on area talent to fill his Susquehanna University wrestling room in the 1960s and 1970s. The Bechtel brothers and Randy Bailey are Selinsgrove High School grapplers who went on to success with the Crusaders. In the front row, cocaptain Bill (left) and Rick Bechtel flank cocaptain Tom McGeoy. Bailey is in the second row, third from the left. All three did very well, with Bill posting a career record of 35-0-3 and gaining induction into the Susquehanna University Athletic Hall of Fame. Both Bechtels were undefeated in 1971.

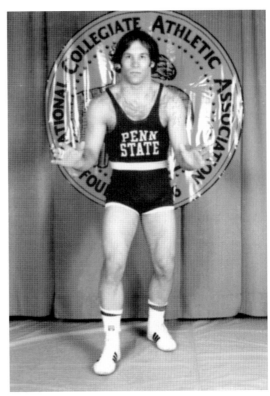

Dave Becker joined Marshall Dauberman as Selinsgrove High's only two PIAA state champions. In 1974, he enrolled at Penn State, winning three Eastern Wrestling League championships and All-America status. State coach Rich Lorenzo said, "If it weren't for Lee Kemp [three-time NCAA champion from the University of Wisconsin], I feel Dave would have won two national championships." Kemp defeated Becker twice at nationals at 158 pounds. Becker's father, Rupert, wrestled at Sunbury High School in the 1950s.

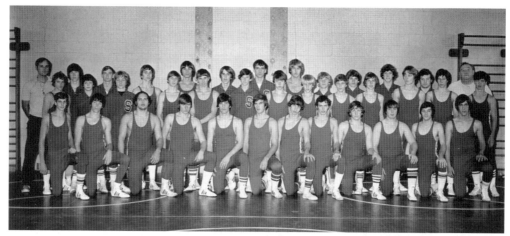

In the 1970s everyone—well, almost everyone—wanted to wrestle for Dick Smoker at Selinsgrove High School. Considering there are 10 weight classes, the squad size indicates stiff competition. Outstanding wrestlers on this 1976 team included Jim Campbell (not the author, but "the real" Jim Campbell), Marlin Van Horn, Todd Burns, Bill Martin, Tony Brubaker, Wayde Walter, Tim Ritter, and Jim Roush.

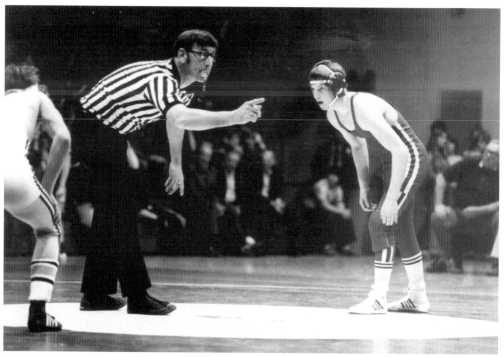

"The real" Jim Campbell (right) was a tremendous wrestler who could have used a little more luck. He finished second in states as a senior in 1977. He kept locking up with two-time state champion Eric Childs of Sayre in the 119-pound class. Campbell enrolled at Virginia's Liberty University, where lady luck continued to desert him—injuries curtailed his career there after two years of mat competition.

GRAPPLING WITH SUCCESS

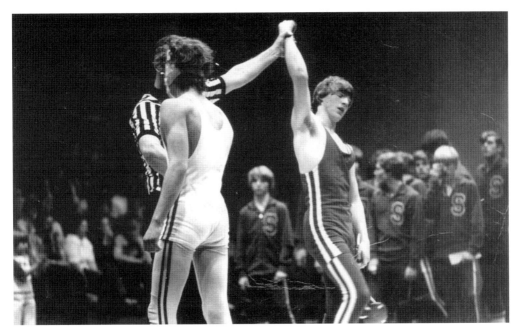

A familiar, even expected sight—note the ho-hum reaction of his mates in the background—was a referee raising the right arm of Jim Campbell in victory after a 119-pound match. During his stellar career, Campbell compiled a record of 76-9-0. Well over half of his 76 victories (43) were by fall. When fans called out, "Show him the lights!" Campbell more often than not did.

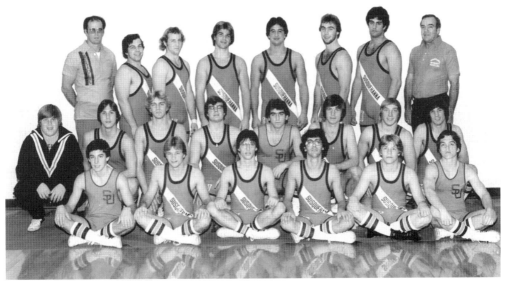

In the late 1970s, Charlie Kunes was still taking advantage of local wrestling talent to fill his Susquehanna University squads. Two of those athletes were members of the 1979–1980 squad: Todd Burns (Selinsgrove), front row, second from the left, and Dave Richards (Danville), front row, third from the left. Richards's father, Dave, graduated from Selinsgrove High and was involved in athletics there.

Steve Deckard was a fine athlete at Selinsgrove High School in football, wrestling, and track and field. When he enrolled at Susquehanna University, wrestling arguably became his best sport. During his collegiate career in the 1980s, he won MAC 190-pound titles as a junior and senior. As a junior, he also placed third in the nation in the NCAA Division III championships, and he finished his Crusaders career with a sterling 65-5-1 record. At the completion of his career, he held numerous Susquehanna University wrestling records.

After considerable success at Selinsgrove High, Todd Myers matriculated at Lock Haven University. He later transferred to Millersville University, where he became a teammate of Selinsgrove High grappler Joel Newman, a third-place PIAA finisher. Myers and Newman are together (back row, third and fourth from the left) on the 1986 Marauders squad. Myers had the misfortune of coming up against six-time national champion Carlton Haselrig (future Pittsburgh Steelers lineman) three times in the NCAA tournament.

OUR NATIONAL PASTIME

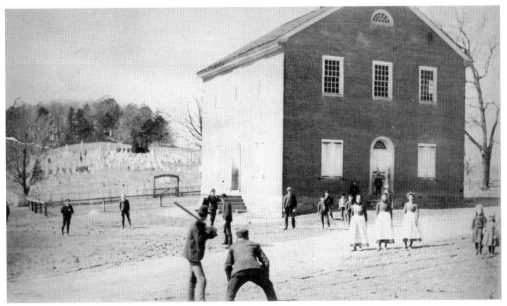

Row's church and the cemetery in Salem are a backdrop for this 1892 photograph. Recess at the nearby Salem School was a time for baseball—at least for the boys. Batting is A. Ira Gemberling. In the group of three nonchalant girls to the right is the batter's sister, Eva Gemberling, who later married the Rev. Alfred Marberger. She is in the middle, the tallest of the trio.

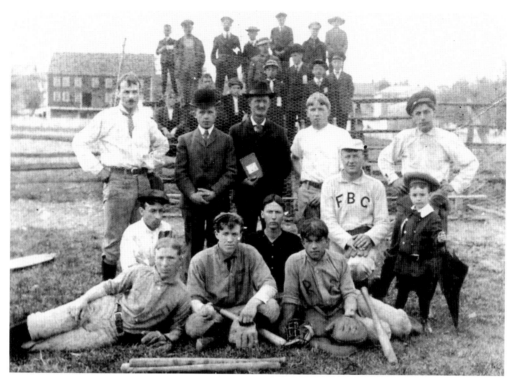

This photograph of the Freeburg Baseball Club from the 1890s is reminiscent of the photographs of town teams in the opening montages of Ken Burns's epic Public Broadcast Service's *Baseball*, a nine-inning tribute to the national pastime. The identities of the ballplayers, and that of the dapper Little Lord Fontleroy at the right end of the second row, are not known.

Still in the Ken Burns mode, this real-photo postcard shows a curly-haired, handsome, young Ray Stettler proudly posing in his Freeburg baseball uniform. The photograph, perhaps taken in his backyard, dates back to around 1905.

The Beaver Springs team of 1908 poses around "Haines big spring." Shown are, from left to right, John Bowersox, Clarence "Mike" Klinepeter, Raymond Wagner, Myron "Brandy" Dreese, Charles "Bonsie" Swanger, William Gilbert, Ott Wagner, Charles Klingler, and George Gilbert. Absent is injured catcher Professor Metzer. Teams of this era walked the considerable miles across Shade Mountain to play archrivals McAlisterville and Richfield.

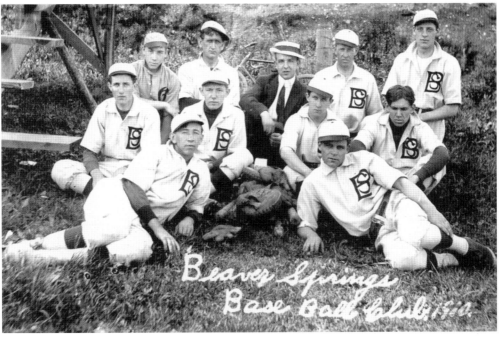

Roy Getz, perhaps taking a sartorial cue from Philadelphia Athletics manager Connie Mack, led this 1910 Beaver Springs team. Shown are, from left to right, (first row) George Gilbert and Charles "Bonsie" Swanger; (second row) Ed Price, Jim Spangler, Myron "Brandy" Dreese, and Sam Wetzel; (third row) Charles Shoop, Clarence "Mike" Klinepeter, manager Roy Getz, Bill Gilbert, and Raymond Wagner.

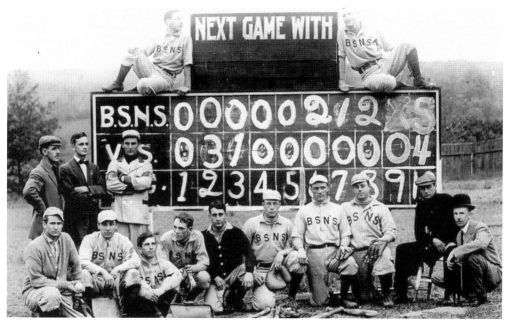

Ralph Mitterling of Freeburg is one of a few Snyder Countians who made "the show," as professional players refer to the majors. He played for Connie Mack's Philadelphia Athletics in 1916. Before, he played at Bloomsburg State Normal School. Mitterling is the sixth player from the left in the front row. He and his mates are celebrating a 5-4 victory over Lock Haven State Normal School on June 10, 1910. Others to play in the majors are Dick Kauffman, Frank Motz, and Paul Musser.

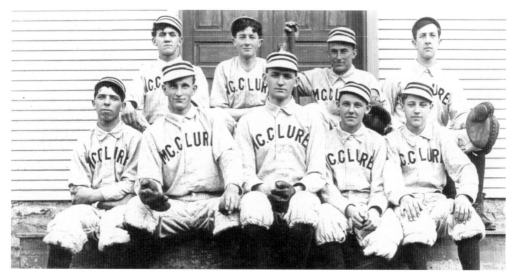

In sharpness of image, this photograph of the *c.* 1910 McClure team rivals that of the 1908 Richfield team published in Images of America: *Snyder County*. Shown are, from left to right (first row) Sam Brininger, Elmer Sipe, Erman Benfer, Emory Heeter, and Jim Krick; (second row) Johnny Snyder, Penrose Hockenbrock, Henry Knepp, and Warren McGlaughlin. The nine played games at Selinsgrove, Lewistown, and points in between.

The stone foundation of long-gone Alumni Gym at Susquehanna University is the backdrop of this real-photo postcard of recent Beavertown High School graduate Ira Middleswarth. The card dates back to 1914. Middleswarth founded the potato chip company that bears his name and is the producer of what is arguably Snyder County's most famous export.

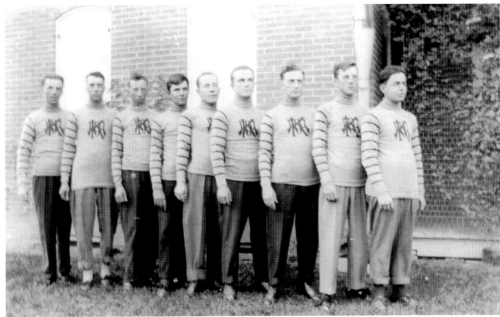

If it were not for Dwight Saxton's positive identification, it may be hard to tell the 1915 Kratzerville baseball team from a British rugby team. Shown in their Kratzerville Athletic Association sweaters (note monogram) are, from left to right, Preston Leitzel, Raymond Herman, Dolan Roush, Ammon Seebold, Jim Lepley, Stan Lepley, Miles Derk, Bright Naugle, and Milo Wetzel.

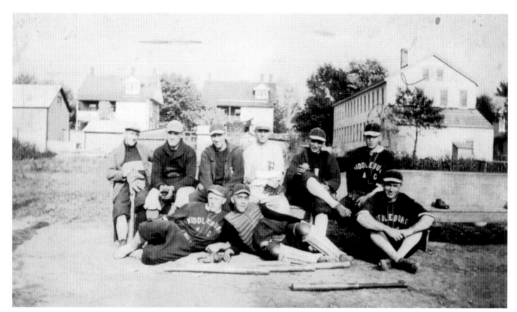

This is the 1919 Middleburg team posing near what is Charles Field. Shown are the starting nine, from left to right, (first row) Earl "Peach" Arbogast, "Punch" Libby, and "Bump" Miller; (second row) Bill Stetler, Allen Schoch, Russell Stettler, Prof. John Kelsey, Jay Bachman, and Paul Felker.

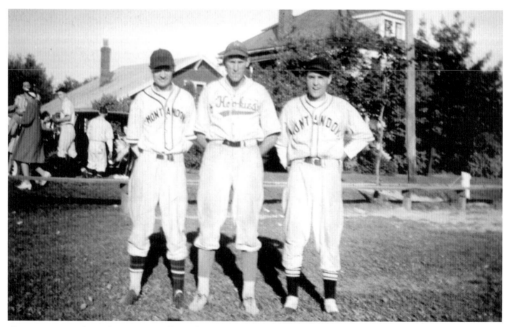

One may wonder why Montandon players, around 1930, are featured in a Snyder County book. Well, there is a connection. Pictured are the three baseball-playing Bollinger brothers, two of whom played at Susquehanna University. Shown are, from left to right, Harold, Marlin "Whitey," and Clarence "Tip" Bollinger. Harold and Marlin are the Crusaders alumni.

This *c.* 1930 photograph is captioned "Murderers Row." No, it is not Babe Ruth, Lou Gehrig, and Tony Lazzeri of the New York Yankees, but Susquehanna University's answer to the hall of fame sluggers. Shown standing from left to right are Sherman Good, Willie Groce, and Al Snyder. The snapshot was taken before the Crusaders played the Flying Dutchmen of Lebanon Valley College in Annville.

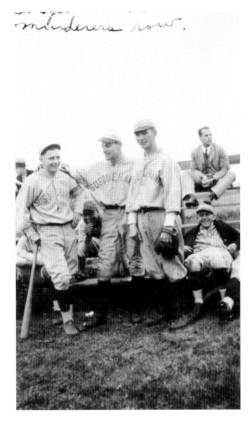

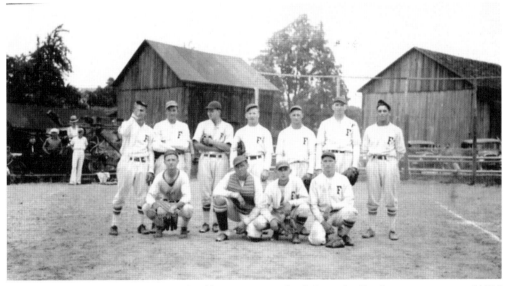

With the barns of Joe Kissinger and Eddie Lauver as a backdrop, the Freeburg town team of 1936 poses for an informal portrait. Shown are, from left to right, (first row) Johnny Walter, Eugene Walter, Warren Miller, and Carl Barner; (second row) a clowning Mick Miller, Stanley Witmer, Earl Barner, Clarence Teats, Charles Glass, Fern Barner, and Elmer Boyer.

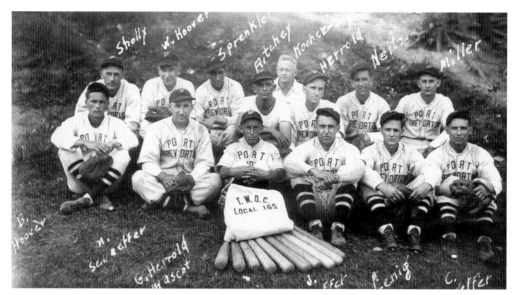

In 1940, the Port Trevorton nine was a formidable group. Shown are, from left to right, (first row) Bob Hoover, Mark Schaeffer, Gene Herrold, Jason Schaeffer, John Lenig, and Clint Schaeffer; (second row) Russ Sholley, Warren "Pete" Hoover, Abe Sprenkle, William "Pete" Ritchey, Ike Kocher, Ken Herrold, Jim Neitz, and Glenn Miller. The "T.W.O.C." on the equipment bag stands for Textile Workers Organizing Committee.

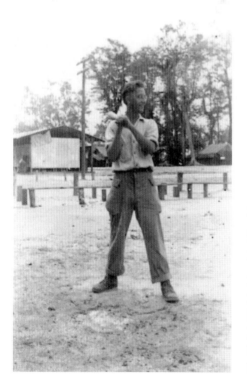

Like many young men, and women, of his generation—called "the greatest" by Tom Brokaw, Lew Ritter served his country in World War II. He was part of the Construction Battalion Maintenance Unit 558 (Seabees). At Hollandia in New Guinea, the Seabees primarily built airstrips, but they also fashioned a ball field. Ritter is shown, around 1944, taking his turn at bat on the field he helped build. Note the combat boots and fatigues—not the usual baseball attire.

OUR NATIONAL PASTIME

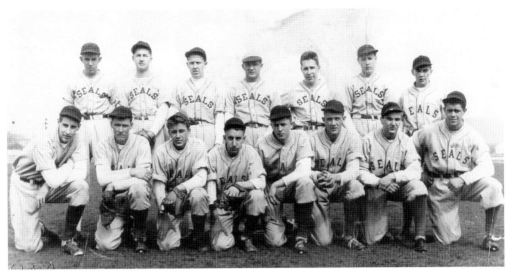

Before many went off to war, the 1944 Selinsgrove High School baseball team played out the season. Shown are, from left to right, (first row) Johnny Reitz, Rudy Nolder, Bob Wilhour, Charlie Rau, George Hepner, Ken Mease, Robert "Duffer" Sheetz, and Dave Coryell; (second row) Charlie Salter, Bob Kuster, George Shaffer, Lester "Buster" Leach, Bob "Smokey" Laubscher, Wilfred "Wimp" Boyer, and Chet Rowe.

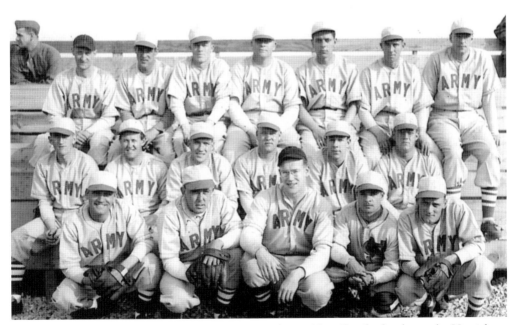

As many Snyder Countians of a certain generation know, New Cumberland—in the Harrisburg area—was an army induction center. Although most inductees were usually shipped out quickly, the permanent party could and did field a baseball team. Charlie Fasold of Selinsgrove, a catcher, is shown (back row, extreme right) on this c. 1944 team. While in the service, Fasold caught Gratz's Carl Scheib—a Philadelphia Athletic's pitcher.

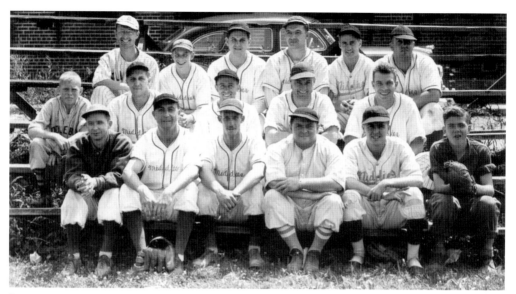

Returning servicemen were anxious to pick up their lives where they left off. Baseball helped. The 1947 championship Middleburg West Branch team is, from left to right, (first row) Les "Lefty" Mitchell, John Gift, Richard "Cracker" Howell, John Schuck, Richard Felker, and Ted Wenrich; (second row) John Snyder, Guy Snyder, Ben Bachman, Harold Neff, and Bob Bachman; (third row) Carl Bilger, Fred Hester, Bill Felker, John Varner, Joel Kuhns, and Gordon "Peach" Arbogast.

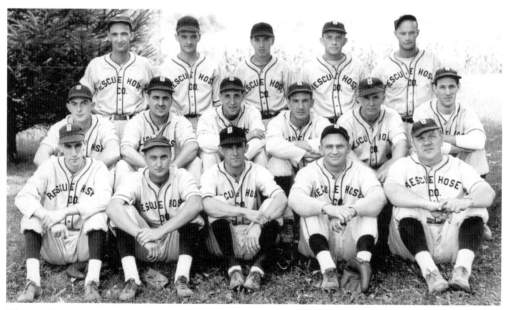

The 1948 Beavertown West Branch team was sponsored by the town's Rescue Hose Company. Shown are, from left to right, (first row) Bill Saylor, Paul Kline, Stan "Hook" Saylor, Josh Hackenberg, and John Coleman; (second row) Rich Coleman, John Saylor, Harold "Dieutch" Wagner, James "Sonny" Herman, Dick Saylor, and Bob Middlewarth; (third row) Bill Markley, Bob Markley, Don "Ziggy" Mattern, Charles "Windy" Saylor, and Don Hoy.

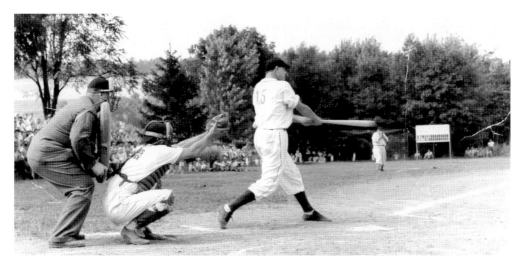

John Gift of Paxtonville was a promising minor-league player in the Cincinnati Reds' organization in 1939 and 1940. Then came World War II. Gift was later a standout with the Middleburg Middies. In his final season, he batted .438. Gift is shown hitting in a 1949 game. Other county professionals, though not on this team, include: Alvin "Towie" Walker, Charles Felker, Jay Bachman, Frank Thomas, Jim Ramer, Ellsworth "Slug" Dean, and Les "Lefty" Mitchell.

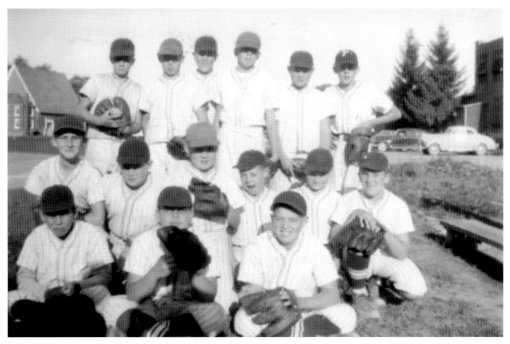

Beaver Springs suited up a Little League team in 1949. Shown are, from left to right, (first row) Sam Hall, Larry Troxell, and Mike Saylor; (second row) LaRay Fetterolf, Roger Wagner, Dallas Ewing, Gary Goss, Bill Haines, and David Aurand; (third row) Gary Norman, Larry Freed, Gerald Aurand, John Shambach, Don Haines, and Ron Wagner. Missing are Ron and Larry Lepley. Bill and Bob Markley managed the team; sister Jean was scorekeeper.

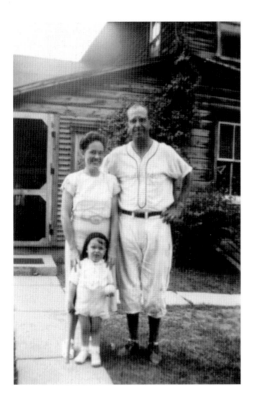

Before going off to play for the Middleburg West Branch team in 1949, John and Carmen Gift and son Bob pose for a snapshot. The reason John is hatless is because his cap is engulfing the head of his young son, who would grow up to be a fine baseball player in his own right.

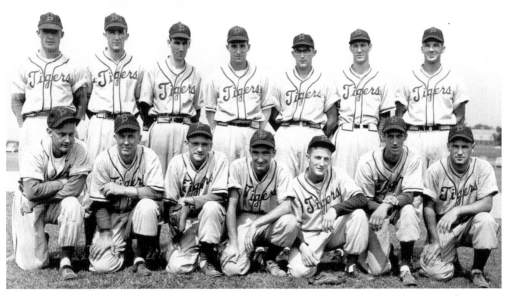

The 1950 Beavertown Tigers were another West Branch championship team—with a 33-3 record. Shown are, from left to right, (first row) Richard Hoy, Richard Saylor, Bob Markley, Bill Markley, Roy Swanger, Richard "Cracker" Howell, and Nelson "Solly" Kline; (second row) John Boonie, Stan "Hook" Saylor, Bill Saylor, Harold "Deiutch" Wagner, Richard Coleman, Bob Middleswarth, and Sam Herman. Not shown is scorekeeper John Coleman

OUR NATIONAL PASTIME

Jim Lash (right), longtime manager of the Beavertown West Branch team was notoriously camera-shy. However, at the league's annual mid-winter banquet, he poses as league official Effinger "Effie" Reichley, a Selinsgrove sporting goods store operator and sports booster, presents the handsome 1950 championship trophy to the Tigers' manager.

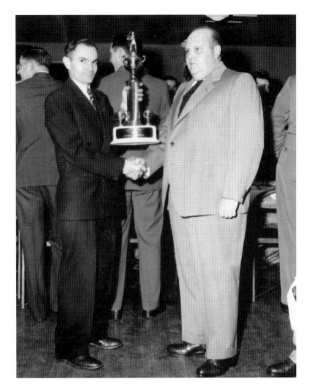

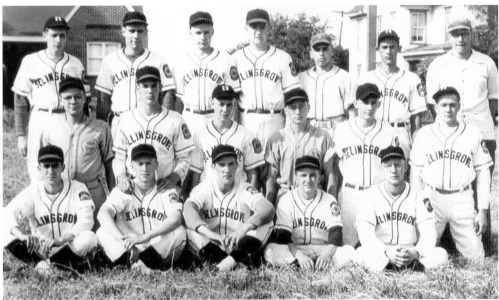

Sponsored by Benner Motors' Ford agency, the 1950 Victory Post 25 American Legion team is shown here. From left to right are (first row) Johnny Robinson, Roger Hepner, Galen Campbell, George Sheetz, and Glen "Jake" Miller; (second row) George Wilhour, Jack Keller, Dick Kretz, Elton Kauffman, Bill Rowe, and Ray Musser; (third row) Charlie Hoover, Donnie Foltz, Davis Clark, Carl Winey, Don Botteiger, Don "Whacker" Krohn, and Larry Romig.

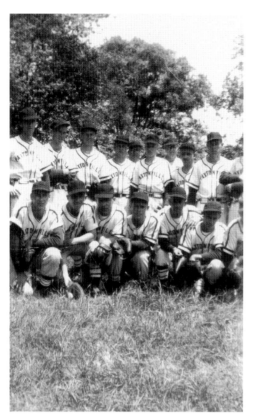

Paxtonville, around 1951, was a hotbed of baseball. Shown are, from left to right, (first row) Sam Gill, Guy Troup, Phillip Graybill, Eugene "Bud" Zimmerman, Albert Gill, and Glenn Treastor (partially obscured); (second row) Bob Treastor, Jim Howell, John Hassinger, Simon "Ted" Felmey, Bruce Spigelmyer, Jack Hestor, Donald Renninger, Stanley Hook, and Arthur "Usher" Gill (partially obscured).

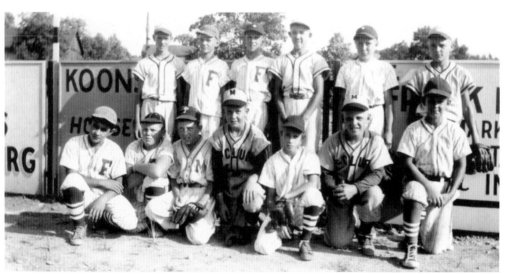

The 1953 Snyder County All-Stars pose in McClure for this team photograph. Shown are, from left to right, (first row) Gary Sheaffer, Dave Snyder, Larry Walter, Tony McGlaughlin, Ron Snook, Jack Wagner, and Ron Saylor; (second row) John Powers, Gary Walter, Bob Reggia, unidentified, Ken Wagner, and "Gino" Marchetti. Many went on to fine careers, with Ken Wagner playing professionally in the Milwaukee Braves system.

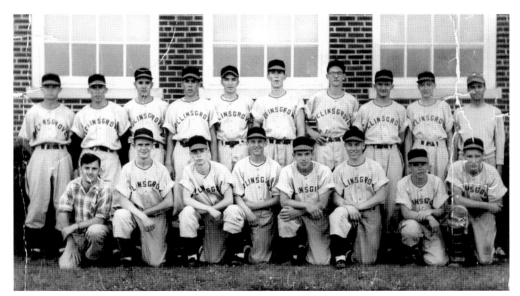

New coach Dick Hummel, who brought a wealth of experience from his minor-league career, led the 1953 Selinsgrove High School team. Shown are, from left to right, (first row) manager Jim Snyder, Al Zerbe, Jim Campbell, Dick Eichenlaub, Bob Hoover, Carson Naugle, Bob Yerger, and Bob Lewis; (second row) Bob Gargie, Harry Hoffman, Neil Bailey, Dean Booth, Bob Rau, Mark Hoffman, Harry Powers, Gerry Herbster, Ed Rhoads, and coach Dick Hummel.

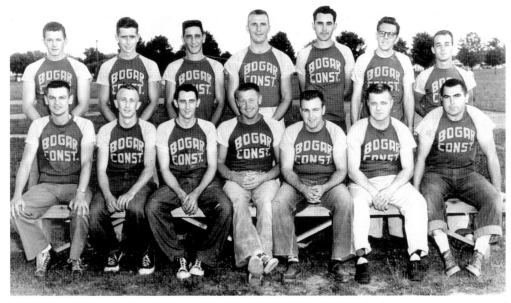

Softball rivaled baseball in popularity in 1953. Bogar Construction of Selinsgrove was just one of many Snyder County teams. Shown are, from left to right, (first row) Ken Krouse, Bob Thomas, Joe Campinini, Wilfred "Wimp" Boyer, Robert "Duffer" Sheetz, John Hornberger, and Mahlon Rathfon; (second row) Hoy Riegel, Bob Seaman, Don Hamilton, Mike Rising, Harvey Murray Jr., Dick Bogar, and Nelson Bailey.

Because of Snyder County spring weather and the early end of the school year, high school baseball was an inexact science, so to speak. But when consistently good weather arrived, American Legion baseball took over. High school–age athletes refined their skills playing American Legion ball. One of those, representing McClure's Post 942, was Bill Weader, who was primarily a pitcher but also played the "hot corner" (third base) on the 1953 team.

William "Bud" Morgan is another athlete who enjoyed American Legion ball in the summer of 1953, playing for Post 942. Morgan, like Bill Weader and others, also played basketball and soccer at McClure High School, but baseball was considered his best sport. He handled the "keystone sack" (second base) with aplomb. Dick Gilbert, Penrose Hockenbrock, and Joe Weader were among others who donned the Post 942 uniform that season.

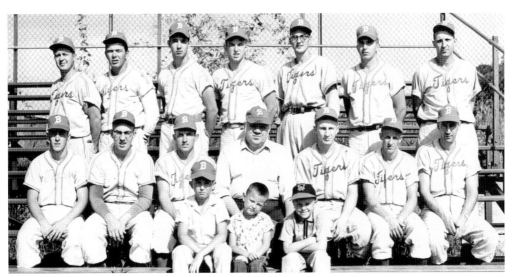

Beavertown was still contending in 1957. However, some new faces appeared. Shown are, from left to right, (first row) batboys Gary and Sid Wagner, and Stevie Solomon; (second row) Dick Moser, Monroe Klingner, Erman Lepley, scorekeeper John Coleman, Ken Wagner, Herb Folk, and Bill Saylor; (third row) Gene Solomon, Ted Wenrich, Gerald Crawford, Ron "Lou" McGlaughlin, Wayne Herman, Don "Ziggy" Mattern, and manager Harold "Dieutch" Wagner.

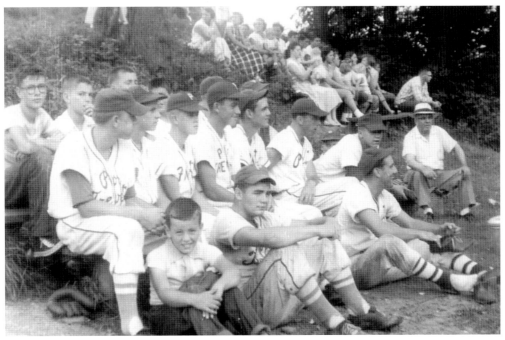

Posing at the same location as the 1940 Port Trevorton team, the 1957 ball club has a rather informal picture taken. Shown are, from left to right, (first row) batboy Frank Mull, Vaughn Wolf, and Galen Campbell; (second row) Larry Herrold, Gary Charles, Ron Stahl, Foster Straub, Terry Wolfe, Don Herrold, and Ron Hoover.

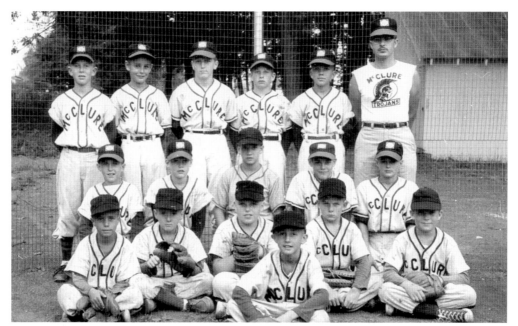

Norman Kline lent his considerable talents to coaching the 1959 McClure Little League team. Shown from left to right are (first row) Greg Snyder; (second row) Alan Romig, Rich Kuhn, Joe Wagner, Donnie Erb, and Alan Peters; (third row) Joey Knepp, Jim Reich, Andy Ward, Ted Kline, and Alan Goss; (fourth row) Keith McGlaughlin, Art Kline, Mel Fleming, Woody Kahley, Roger Pheasant, and coach Kline.

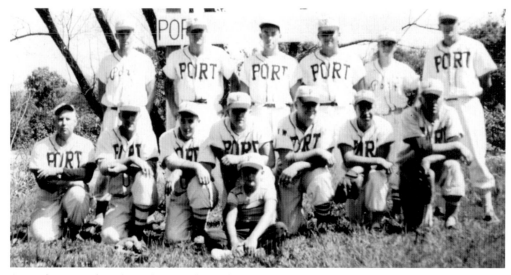

Several years and uniforms later, in the early 1960s, the Port Trevorton team poses in front of the Miller Insurance–sponsored scoreboard. Shown are, from left to right, (first row) Clint Schaeffer, Galen Campbell, Charlie Hoover, Ron Hoover, Vaughn Wolf, Robert "Peewee" Herrold, and Larry Herrold; (second row) Don Herrold, Louie Williams, Foster Straub, Dean Hoover, Mark Reed, and Loyal Jones. Batboy Rickey Schaeffer is in front of the team.

OUR NATIONAL PASTIME

Joe Joyce, pictured at Susquehanna University in 1961, typified the hold baseball has on the country. A versatile athlete at Ashland High School, he concentrated on baseball at Susquehanna. He later coached sons Joe and Mike and others in Little League and took extended "spring training vacations" for the rest of his life. The Joyce and Bollinger families contributed substantially in honoring Harold Bollinger with the naming of Susquehanna University's baseball field.

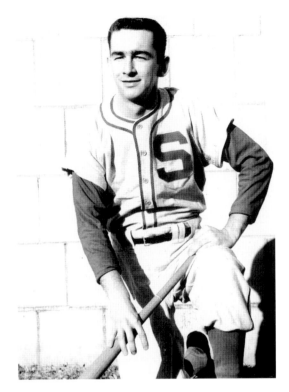

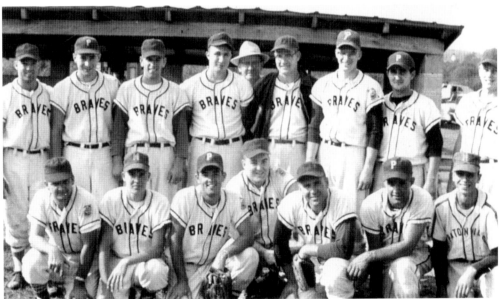

Pictured around 1963 are the Paxtonville Braves, champions of the West Branch League. Shown are, from left to right, (first row) Ben Bingaman, Bob Gift, Gary Gill, Richard Herbster, Sam Gill, George Herbster, and Ken Herbster; (second row) Ken Zechman, Lester Simonton, Jim Gill, Mark Zechman, manager Jim Howell (in brimmed hat), Sam Curtis, Dale Hackenberg, Rich Hackenberg, and Rich Snook.

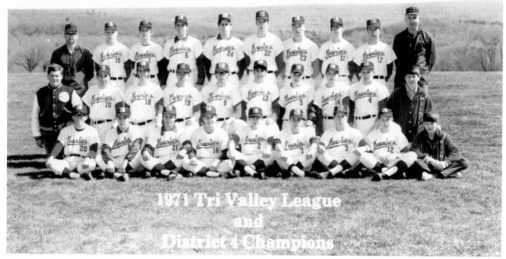

From 1969 to 1971, West Snyder was District 4 champion. The 1971 team is shown here. From left to right are (first row) D. Smith, D. Middleswarth, M. Erb, K. Krick, C. Young, C. Bingman, J. Snyder, Doug Rigel, and R. Wagner; (second row) M. Lash, G. Graybill, J. Butler, G. Fogel, S. Wagner, R. Rager, S. Knepp, D. Mattern, Duane Rigel, and R. Keiser; (third row) J. Botdorf, L. Dean, I. Hassinger, S. Hassinger, J. Aumiller, R. Arnold, A. Jones, M. Church, J. Graybill, and T. McGlaughlin.

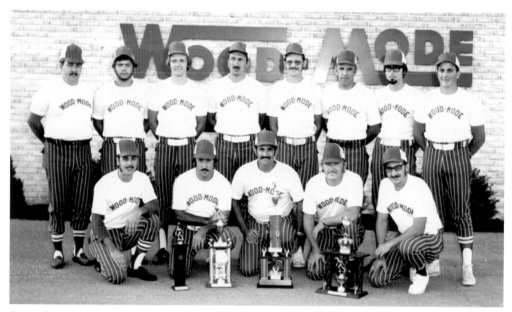

Several trophies are displayed by the 1975 Wood Mode softball team. Responsible for the loot are players who worked for Snyder County's leading employer. Shown are, from left to right, (first row) Ken Herbster, Gene Ritter, Bill Zechman, Chuck Kratzer, and Barry Ulrich; (second row) Rich Herbster, Dean Walter, Roger Clotfelter, Mark Zechman, Joe Osgood, Jim Gill, Joe Felker, and Darvin Zechman.

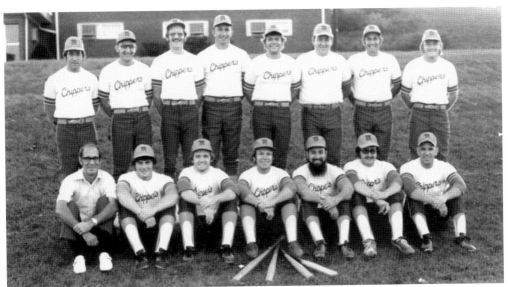

The 1976 Middleswarth Chippers, sponsored by Middleswarth Potato Chips, of course, show off their professional-style uniforms. Shown are, from left to right, (first row) Bob Middleswarth, Darvin Zechman, Roger Clotfelter, Sam Herman Jr., Ken Herbster, Del Ritter, and Sam Gill; (second row) Gene Ritter, Barry Ulrich, Joe Osgood, Mark Zechman, Dean Walter, Rich Herbster, Bill Zechman, and Chuck Kratzer. Note roster similarity with the 1975 Wood Mode team.

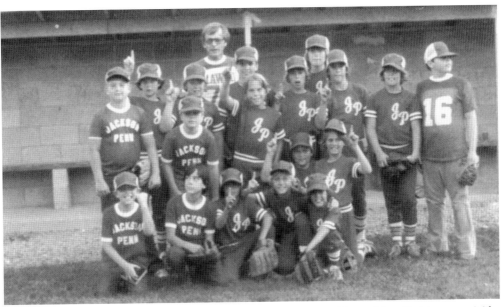

The Jackson-Penn Little League champions of 1978 are pictured here. Identified here are Mike Yoder, John Gallagher, Jon Bailey, Troy Cover, Chris Bailey, Tim Dressler, John Norton, Shawn Andrulewicz, Chris Grove, Todd Benner, John Kenner, Greg Russell, Todd Hoot, Chris Wagner, David Housley, Mark Slear, John Mull, and Dean Kerstetter. Coach Ray Benner is behind the players. Absent is Paul Felker.

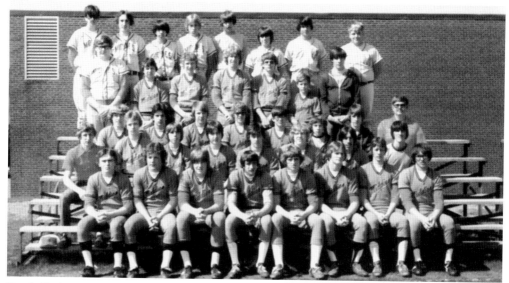

Baseball, for many years, was the first organized sport most kids played. Now soccer has made inroads with American Youth Soccer Organization (AYSO) teams. In the spring of 1979, when the Middleburg High School varsity and junior varsity posed for the above photograph—before the soccer explosion—baseball was still the national pastime in many schoolboys' minds. Stanley Shaeffer coached the Middies at this time. Daryl Shirk, also a great wrestler, was the team's MVP.

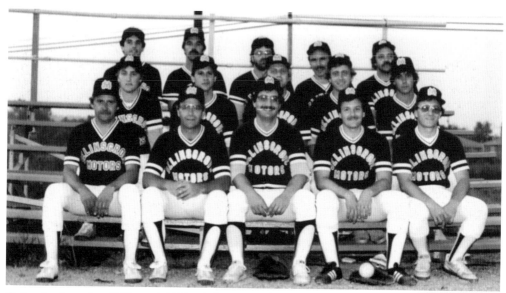

Going back to the 1940s and 1950s, Selinsgrove Motors (now Selinsgrove Ford) was a sports sponsor. Pictured is the 1980 championship team. Shown are, from left to right, (first row) Jim Youngman III, Lonnie "Turk" Groce, Barry Miller, Duane Rigel, and Randy Shaffer; (second row) Jeff Doak, Randy Wolfe, Dale Miller, Billy Teischer, and Jim Youngman IV; (third row) Scott Lizardi, Brad "Skip" Dreese, Brad Hollenbach, Jeff Shawver, and Bill Wimer.

Running, Jumping, and Throwing

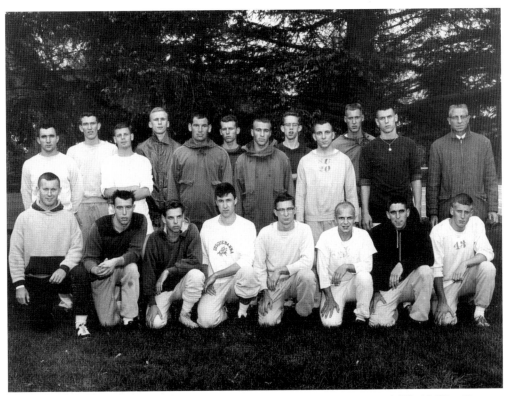

Track and field was a prominent sport at Susquehanna University until World War II came along—then the sport was discontinued "for the duration" and beyond. In the spring of 1960, Blair Heaton (back row, extreme right)—arguably the finest all-around track and field man in Crusaders history—reinstated the sport. In addition to coaching, before meets he would "roll" the track himself, rake the jumping pits, and lug the heavy wooden hurdles into place. As one can see, there were also no state-of-the-art warm-up suits.

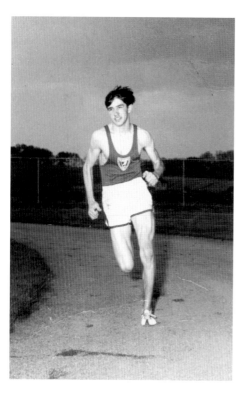

Don "Homer" Ernst was by his own admission "an average cross-country runner" at Selinsgrove High School. However, the summer after graduation, he worked long and hard hours at Furman's cannery. When he matriculated at Thiel College in the fall of 1969, his skill level—not to mention speed, stamina, and endurance—increased dramatically. As a Tomcats cross-country runner, he consistently placed in the top five finishers in dual meets and placed among the leaders in the conference championship race.

Bob Shadle, Selinsgrove High athletic director, casually announced in the faculty lounge one day in 1962 that Selinsgrove High School was "going to start a track and field program." Jim Taylor thought that was great and asked who the coach was going to be. The athletic director said, simply, "You!" The rest, as they say, is well-documented history. Taylor is shown going over strategy with 1974 team captain and sprinter Joe Klein (left). Selinsgrove remains the only county high school with an expansive track and field program.

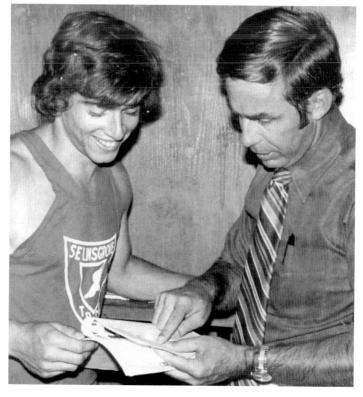

The foundation for a PIAA state championship at Selinsgrove was laid in the mid-1970s by a squad like the one pictured here. The 1976 state championship was the culmination of coach Jim Taylor's dynasty. From 1962 to 1977, Taylor posted a 122-37-0 record. Don Wilhour, a great performer under Taylor and at Indiana University of Pennsylvania, took over and added luster to the program. Between 1978 and 2001, Wilhour carved out a 214-3-1 record, including a state-record 158 consecutive dual wins.

Several of the many medal winners from the 1976 PIAA state championship Selinsgrove High School squad were the 4-by-800 relay runners. The quartet of half milers poses with its medals and trophy. Shown are, from left to right, Kip Sassaman, Dave Lauer, Craig Foltz, and John Payne. It would appear that Lauer ran right out of his shoes.

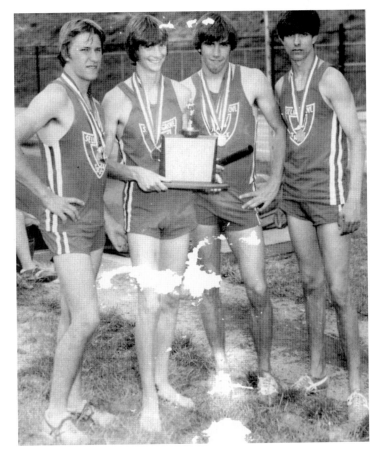

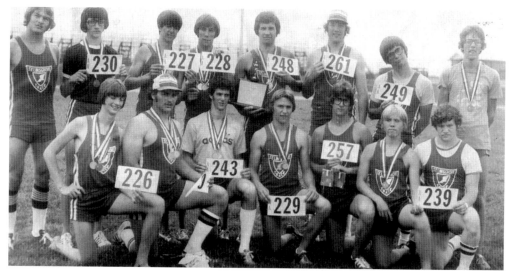

To say the 1976 Selinsgrove High School track and field team ran away with the 1976 PIAA state meet may be an understatement. Qualifiers shown are, from left to right, (first row) Dave Lauer, Marlin Van Horn, Mike Fahnestock, Kip Sassaman, Mike Neff, Kevin Horlacher, and Eddie Lockcuff; (second row) Kerry Becker, Charlie Attig, John Payne, Craig Foltz, Charlie Conz, Todd Aungst, Jeff Lewis, and Kevin Kinney. The squad was crowed state champion.

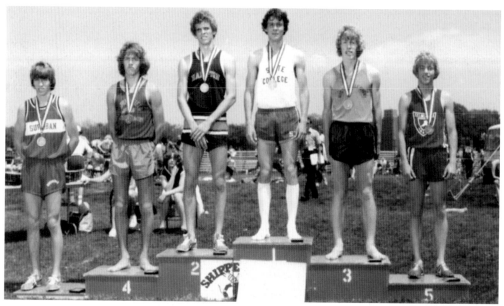

Larry Smith (extreme right) is one of the great runners of Selinsgrove's track and field program. Under coach Don Wilhour, he placed fifth in the mile at the PIAA state championship meet in 1978—shown here at the awards ceremony. In 1979, he was second at states in the 800 meters. His speedy 4:18.1 of 1978 at state is still the Selinsgrove High School mile/1600-meter record. His 9:43.8 in the 3200 meters—run in 1979—is a record as well. Coach Wilhour says, "He *always* ran a strong race."

RUNNING, JUMPING, AND THROWING

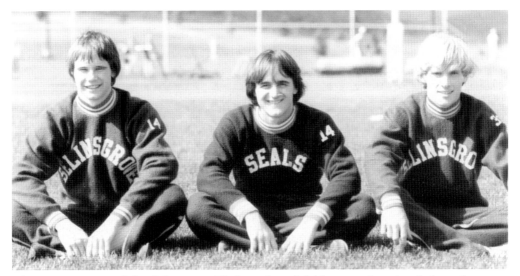

The 1979 captains of the Selinsgrove High track and field team take a break from the rigors of practice to pose for an informal portrait at the high school field. Shown are, from left to right, Chris Anderson, Joe Lenig, and Randy Phillips. The Seals now run on a state-of-the-art track, but in this era, they ran on cinders. Outsiders are still amazed at the quality of the Seals' performances on such a crude facility.

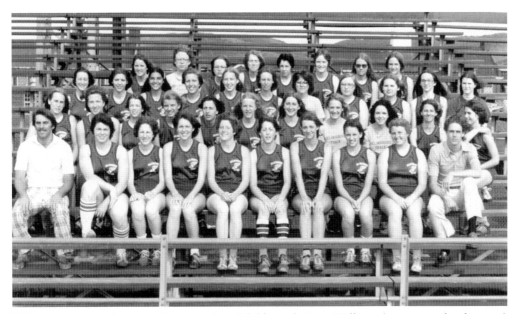

Before becoming a legend as boys' track and field coach, Don Wilhour (extreme right, first row) inaugurated a girls' program at Selinsgrove High in 1976. Pictured is his 1977 squad, which includes Laura App, Fay Bonawitz, Julie Carr, Laura Dauberman, Brenda Gibson, Debbie Hartman, Colleen Hook, JoEllen Malloy, Debbi Rhoads, Stacey Reed, Shelly Ressler, Dixie Sassaman, Valerie Slear, Mary Sullivan, Kathy Taylor, Brenda Tumolo, and Darla Walter. Donna Prince and Dave Lauer followed Wilhour and added much to the program.

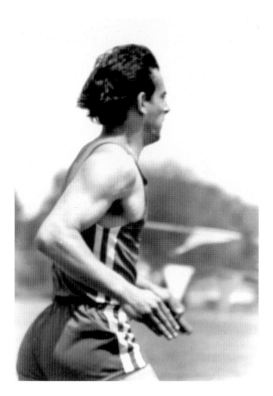

Setting a blistering pace as a freshman and sophomore, Jeff Holdren contributed greatly to the Seals in the early 1980s. He still holds the freshman and sophomore records in the 400 meters many years later. Holdren's frosh time was 51.8, his sophomore time 51.3. The 400 is thought by many track coaches and participants to be the most grueling event. It has long been a "sprint." Quarter milers such as Holdren are the nucleus of any track and field squad. Holdren is shown running as a junior in the District 4 meet at Williamsport.

Baton in hand, Todd Hershey is running as part of a 1980s Selinsgrove High School 4-by-800 relay team. Along with fellow runners Rick Lybarger, Todd Schreffler, and Dave Bodmer, the quartet set—and still holds—the school record for the event. They were the seventh-fastest relay team in the state at the time.

RUNNING, JUMPING, AND THROWING

While compiling a winning mark of 99 percent as head track and field coach at Selinsgrove High (1978–2001), Don Wilhour had virtually the same assistants the entire tenure. Shown are, from left to right, George Hummel, Wilhour, and John Tini. From 1978 to 2000, the red and blue runners, jumpers, and throwers tasted defeat only three times in dual-meet competition. Former Seals field events performer Brian Catherman is currently Selinsgrove High School head coach, continuing the rich tradition.

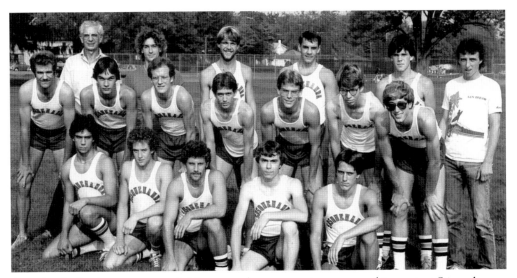

Stan Seiple (back row, extreme left), a marathon competitor, was working out at Susquehanna University's track in the late 1970s when he saw a notice asking for a cross-country coach. He volunteered and produced many championship squads. These are his fall of 1982 harriers. They tied the University of Scranton in their opening meet and then went undefeated the rest of the season, including a 31-25 victory over Scranton in a rematch. Seiple was recently inducted into the Susquehanna University Athletic Hall of Fame.

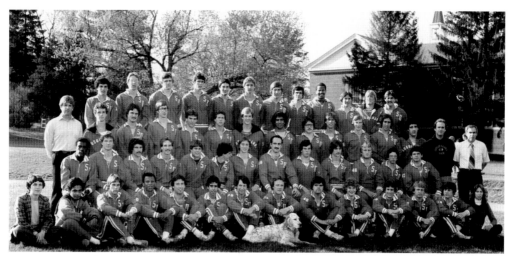

Jim Taylor first went to Susquehanna University as an assistant football coach but soon took over the moribund track and field program. As he had done at Selinsgrove High School, he quickly turned it into a dynasty. After a 4-6 record in his first year, he strung together a bunch of MAC championships. Shown are the 1981 squad and its English setter mascot. Coach Taylor is at the extreme right of the third row.

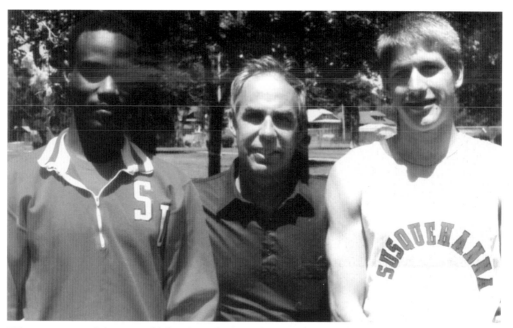

What is pictured here could be described as the "gold standard." Susquehanna University freshman Jeff Walden (left) won the Division III national championship in the 400 hurdles in 1985. Jim Taylor (center) won multifarious championships as a coach. Mike Spangler won gold twice at the 1985 championships—in the 200 and as a member of the winning 4-by-400 relay team. Spangler, who came close to winning an Olympic berth in the 400, was a four-year national champion.

RUNNING, JUMPING, AND THROWING

HOORAY FOR OUR SIDE!

In 1920, the year that this photograph was taken, Lake Chautauqua in southwestern New York was a popular resort—and still is. Testing the waters are three fashionably attired young ladies. Shown are, from left to right, Meriam Gill, Harriet Taylor, and Harriet's sister. Meriam Gill, whose married name is Markley, lived for many years in the Beaver Springs area, and in her 107th year, she was the 2006 Beaver Springs Heritage Days queen.

As stated elsewhere, athletic opportunities for girls and women were limited prior to the enactment of Title IX in the 1970s. High school girls could contribute by supporting male schoolboy athletes in their on-field endeavors. Grace Rice, shown in 1932, typifies those young women. She cheered enthusiastically for Selinsgrove High School's red and blue all during her high school years. She may be remembered better as Gracie Stevenson.

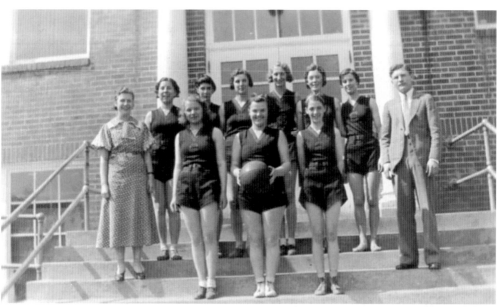

One of the few sports available to high school girls was basketball. During the 1933–1934 season, McClure High School put a squad on the court. Shown are, from left to right, (first row) Ruth Krick, Freida Searer, and Bernice Wertz; (second row) manager Beatrice Knepp, Mae Wagner, Arlene Brininger, Gertrude Klinger, Winifred Rager, Pearl Arnold, Julia Snook, and coach Sherman Good. Good coached most, if not all, sports at the school.

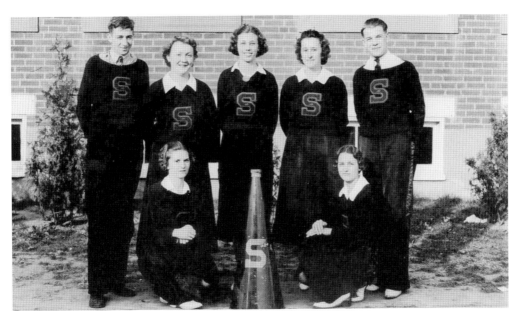

Despite a mediocre football season (3-4-1)—the Great Depression forced many potential athletes to choose after-school jobs over extracurricular activities—the Selinsgrove High cheerleaders of 1936–1937 continued undauntedly to lead cheers. Shown are, from left to right, (first row) Ruth Dunkelberger and Jean Belle Fisher; (second row) George "Corky" Fry, Esther Helen Fisher, Beatrice Meyer, Lillian Stroh, and Earl Gaugler.

The seventh- and eighth-grade Selinsgrove girls formed an after-school gym club, strictly an intramural activity, during the 1941–1942 school year. They pose on the back steps of the old high school gymnasium. Shown are, from left to right, (first row) Jean Ludwig, Shirley North, and Mary Herman; (second row) Helen Keiser and Henrietta "Herky" Hillbish.

There is something about the outdoors and a couple of fast sets of tennis that has universal appeal. In the summer of 1943, Beaver Springs area residents (from left to right) Jean Markley, her mother Meriam, and June Bingman appear ready to answer the proverbial question, "Tennis, anyone?"

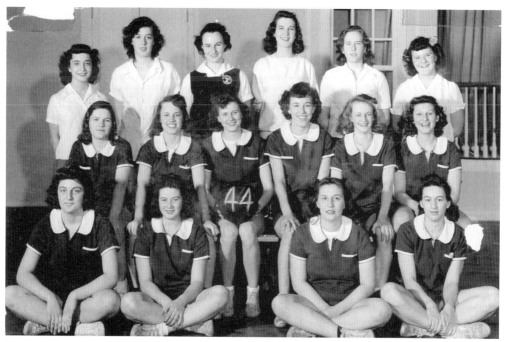

Played at Selinsgrove High School in the 1920s, basketball was dropped in the 1930s. Coach Adele Lebow revived the sport in 1944. Shown are, from left to right, (first row) Esther "Soapy" Savidge, Gerry Kratzer, Josie Jacques, and Henrietta "Herky" Hillbish; (second row) Helen Keiser, Renee "Ronnie" Mowles, Joan Hillbish, Jean Rice, Shirley Slear, and Louise Follmer; (third row) Shirley North, Joanne Houtz, coach Adele Lebow, Judy Bilger, Peg Day, and Mary Jane Kuster.

HOORAY FOR OUR SIDE!

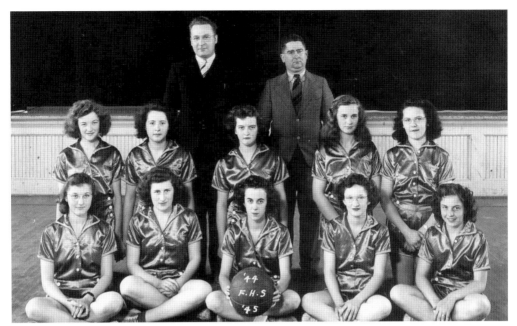

Shiny satin uniforms are the hallmark of the 1944–1945 Freeburg High School Bears girls' basketball team. Shown are, from left to right, (first row) Anna Louise Fetterolf, Doris Garman, Arlene Reinard, Orpha Bottiger, and Mary Mull; (second row) Anna Dreese, Betty Troutman, Letha Garman, Mary Jane Betzer, and Lorena Kepler; (third row) coaches Paul Roush and Robert Workman.

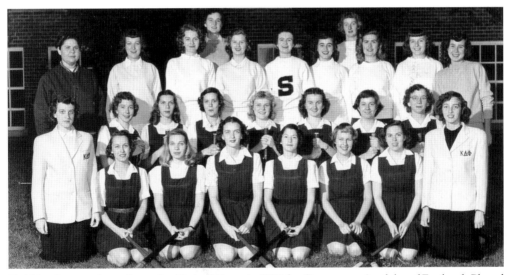

Field hockey was brought to the United State in 1901 by Constance Appleby of England. Played mainly at eastern boarding schools for girls, it gradually spread to the high schools and colleges. This is the 1949 Susquehanna University squad. It is also the cover background photograph. Shown in the middle row, fifth from the left, is Barbara Stagg, daughter of Arvilla and Amos Alonzo Stagg Jr. and a Selinsgrove High School graduate.

To be proficient at cheerleading—as with playing football, basketball, baseball, or any other sport—an early start is an advantage. In Selinsgrove, this group began in junior high during the 1950–1951 school year. Most continued cheering through high school. Shown are, from left to right, Helen Benner, Gloria Schuck, Barb Mattern, Joy Metzger, Jane Schuck, and Roberta Swank.

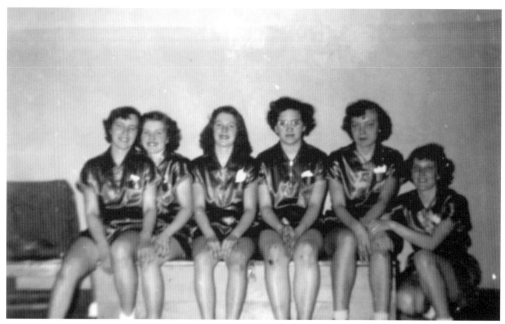

Coach Marlin Shearer had a quality starting lineup in putting the 1952–1953 Beaver Vocational High School girls' basketball on the court. Carrying the school colors, purple and gold, are, from left to right, Elda Wagner, Wadena Snook, Patsy Snook, Martha Thomas, Carol Zechman, and Nancy Goss. Like their male counterparts, the girls competed in the Snyder County League.

HOORAY FOR OUR SIDE!

As closely as McClure High School and Beaver Vocational High School were geographically, an intense rivalry was sure to develop—and it did! Shown, along with the Beavers cheerleaders, is a representation of the archrival Trojans. From left to right are Connie Bowersox, Shirley Snook, Nancy Bailey, and Margie King. The photograph was taken before the big game in 1953.

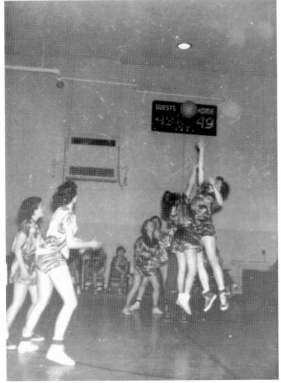

Not many action shots of girls' basketball in the 1950s survive, but this one has. It is Beaver Vocational High School vs. Freeburg High School in 1953. Beaver Vocational players are in the darker uniforms. Identified are Wadena Snook (far left), Patsy Deppen (looking on in the middle), and Patsy Snook (jumping). A look at the scoreboard will tell you it was a close, hard-fought game—49-49 at the time.

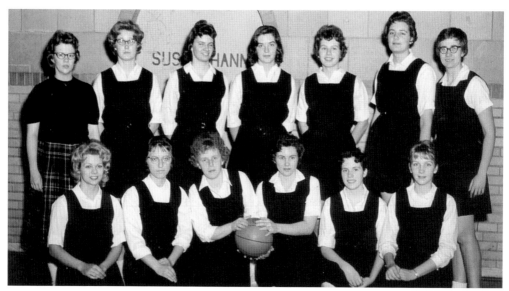

In 1960–1961, coach Betsy McDowell (extreme right, back row) had a talented group of women basketball players at Susquehanna University—none more so than Toby Brodisch (third from the right, back row). Brodisch, perhaps better known now as Toby Skinner, dominated both sports the university offered women at the time—field hockey and basketball. She may have been the *best* athlete in the class of 1963—not just the best female athlete. Fittingly, Brodisch is a Susquehanna University Athletic Hall of Fame inductee.

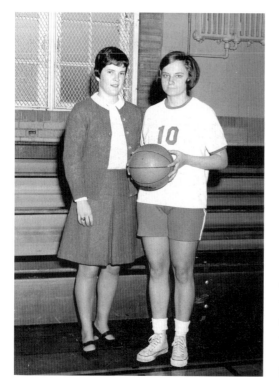

Donna Spancake (No. 10) was an outstanding all-around athlete at Selinsgrove High School in the late 1960s, and just as importantly, she was also an outstanding student. She matriculated at Susquehanna University and played basketball at a level that warranted her being chosen captain of the 1970–1971 team. She is shown with coach Sharon Taylor.

HOORAY FOR OUR SIDE!

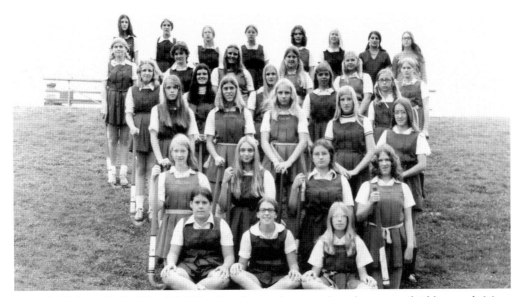

The Middleburg High School field hockey dynasty's strong foundation was laid by coach Mary McClellan and her players. This is the 1974 squad. Shown are, from left to right, (first row) Robin Shaffer, Pat Rapp, and Bonnie Landis; (second row) Sue Shirk, Lori Bickhart, Pam Kratzer, and Donna Miller; (third row) Darlene Graybill, Margi Griffith, Cindy Broscious, Stacey Nailor, and Beth Hackenberg; (fourth row) Julie Stettler, Rae Ellen Spotts, Carol Walter, Tina Kerstetter, and Sue Nornhold; (fifth row) Deb Shadel, Roxanne Deitz, Pat Foltz, Melanie Garman, Cathy Rowe, and Loretta Laudermilch; (sixth row) Rebecca Winey, Gloria Shrawder, Sharon Reigle, Bobbi Bilger, Pat Shaffer, Lori Knepp, coach McClellan, and Joyce Holt.

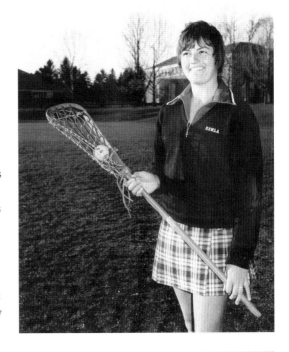

Only a few female athletes every achieved the level of play that Rose Ann "R. A." Neff of Freeburg attained at Selinsgrove High School. She starred in all girls' sports at Selinsgrove, played high-quality field hockey at Lock Haven University, and was introduced to lacrosse. So proficient was Neff at her new sport that she was chosen for the women's national team. She is shown in 1975 in her women's national lacrosse team warm-up top. Neff played on the United States team, which successfully toured overseas, from 1974 to 1976.

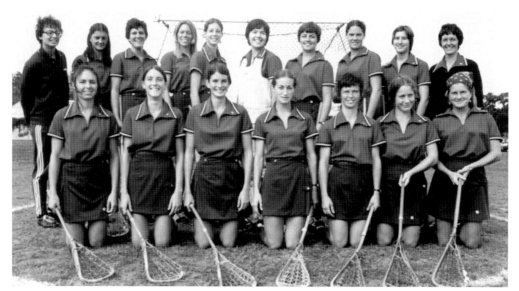

Pictured on the United States women's lacrosse national team in 1975, Rose Ann Neff (back row, fourth from the right) was a strong contributor. Neff and her mates lifted coach Kathy Heinze's team to a memorable 8-6 victory over a stellar Great Britain national team in merry olde England in 1975. Neff's post-playing career includes stops at Susquehanna and Lock Haven Universities as both a coach and athletics administrator. She was also a member of the U.S. field hockey national team.

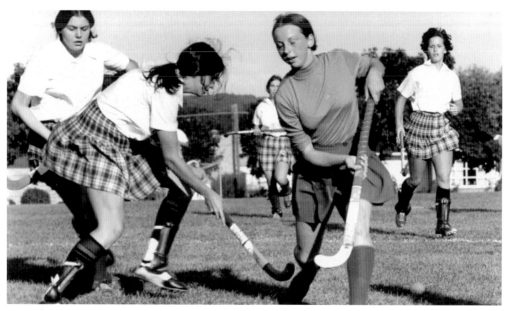

Field hockey may well be the most traditional of girls' and women's fall sports. Few things compare to a well-played game on a crisp late-summer or early-fall day. Shown here is Selinsgrove High School's Cathy Leitzel (dark shirt) being surrounded by players from archrival Shiklellamy High School. The action took place in the fall of 1976.

HOORAY FOR OUR SIDE!

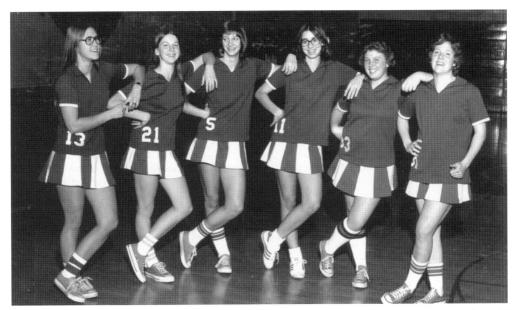

When the game was not on the line, the seniors of the 1976–1977 Selinsgrove High girls' basketball squad shared some lighter moments. Once the game was being played, they were quite serious and business-like. Shown are, from left to right, Terri Fisher, Cathy Leitzel, Debbi Rhoads, Jill Lizardi, Julie Carr, and JoEllen Malloy.

As much a part of high school football as the "Friday night lights" are the pretty, perky, peppy cheerleaders. Pictured in the fall of 1977 is Carol Vance of Selinsgrove High. She and her fellow cheerleaders had much to cheer about—the Seals, under coach Bill Scott, posted an impressive 10-1 mark, including a satisfying 28-6 victory over the Braves of neighboring Shikellamy High.

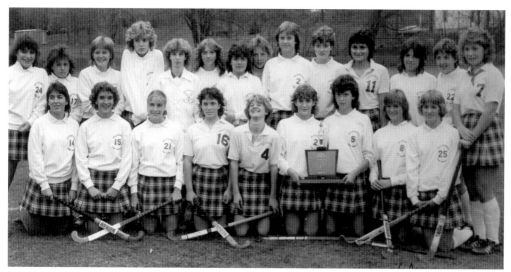

Cathy Keiser is a legendary Selinsgrove High School field hockey coach. This is her first, of many, District 4 title teams (1984). Shown are, from left to right, (first row) Damiata Hoover, Barbie Cawthern, Judy Young, Missy Burd, Tanna Charles, Jill Sholley, Mel Scholl, Chris Rinsland, and Becky Kerstetter; (second row) Gina Hockenberry, Amy Ritter, Judy Feldmann, Lori Weider, Leanna Brown, Chris Schreffler, Brenda Doebler, coach Cathy Keiser, Shannon Rothermel, Amy Troup, Kathy Klingler, Andrea Attkisson, Julie Sholley, and Linda Meiser.

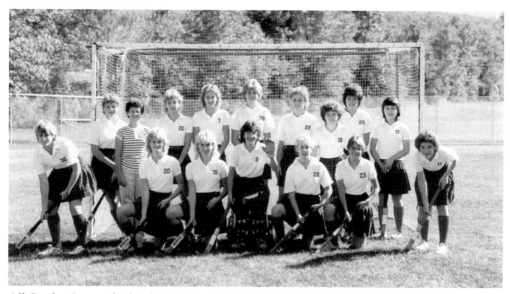

All Snyder County high schools play field hockey to a high standard. Harriet Botdorf led the program at West Snyder High School. Pictured is the 1984–1985 squad. Shown are, from left to right, (first row) Cathy Shawver, Kristin Goss, Roz Camp, Crystal Henry, Annette Weaver, Candy Worrel, and Danielle Boyer; (second row) Angie Narehood, coach Harriet Botdorf, and Michelle Boyer; (third row) Kelly Goss, Tonya Kramer, Tanja Troutman, Denise Ettinger, Caryn Craig, and Teresa Jordan.

THE GREAT OUTDOORS

Shortly after the beginning of the 19th century, Sue Anna Stroup (née Yerger)—a recently wed Beaver Springs resident, joined her husband, Calvin, in moving to the vast plains of South Dakota. Sue Anna stands with a rifle while Calvin holds the rack of a good-sized buck. The family dog also shows an interest in the result of the day's hunt. It is not known whether Sue Anna or Calvin bagged the buck.

Shown in his 95th year (in 1915), Daniel Ott was a true son of the Old West. Born in the Monroe Mills area (35 years before that section would officially be part of Snyder County), he established a reputation as a hunter/trapper/fisherman. In 1842, he *walked* to Chicago and signed on with Buffalo Bill Cody to provide venison and buffalo meat to the Union Pacific Railroad workers. After returning to Snyder County, he would go to Sunbury to meet Cody when his Wild West show's train passed through.

Previous Snyder County books have mentioned the important part Rolling Green Park played in the recreational lives of area residents. The Peoples' Playground, opened in 1909, was an irresistible attraction. Sunday afternoons were a particularly popular time to ride the Sunbury and Selinsgrove trolley to the Hummels Wharf amusement park. Shown in front of the merry-go-round, shortly after its 1914 debut, are Snyder Countians Samuel Trutt and wife Minnie.

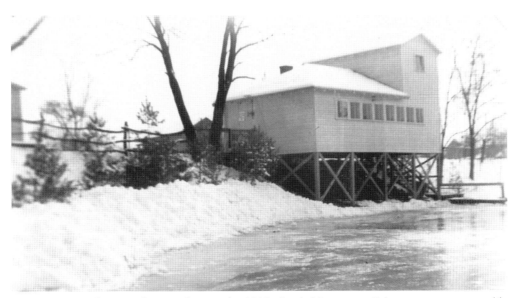

Although this photograph was taken in the 1940s, Little Norway in Selinsgrove is inextricably linked to Rolling Green Park. The mere mention of either place brings pleasant memories flooding back to those who were fortunate enough to have taken advantage of the recreational activities they provided. Younger generations long for something comparable to these facilities. Little Norway, operated mainly by the Burns family, was a winter wonderland from 1938 to 1968 and the site of Ice Bowl football games before it was flooded for the winter.

It does not take much imagination to picture the first American automobile race taking place as soon as there were two cars in the same vicinity—late in the 1800s. Speed, cars, and racing seemed an inevitable mix. In the 1920s, George Ocker, at his Troxelville garage, rigged an old automobile to resemble a speedster. All too happy to be part of the racing team is young Ed Blee, also of Troxelville.

Not satisfied with the condition of the athletic field at Beaver Vocational High School, coach Marlin Shearer enlisted a 1936 physical education class to improve it. Shown are, from left to right, (first row) F. Krebs, F. Loudy, P. Soles, E. Narehood, and C. Walter; (second row) D. Seasholtz, H. Moyer, B. Mattern, and J. Kearns; (third row) R. Thomas, G. Wagner, P. Yetter, G. Bingaman, and W. Weaver; (fourth row) N. Wetzel, M. Napp, E. Freed, R. Sassaman, and R. Eisenhauer; (fifth row) C. Wagner, D. Klinepeter, W. Grimm, W. Wiand, and E. Gross.

In the days before community pools and above-ground and in-ground family pools, sudden summer showers provided impromptu opportunities to get one's feet wet, so to speak. Sporting the latest—if somewhat overly modest—in 1940 swimwear are five-year-old Carol Campbell and her three-year-old brother.

THE GREAT OUTDOORS

Documented here is a 1948 combination "fishing trip and wiener roast." Considering the "catch list," it is good someone brought the hot dogs. Shown from left to right, with the number of fish caught in parentheses, are (first row) Billy Hetherington (0) and John "Butch" Troutman (0); (second row) Harold Aucker (0), Dale "Zeke" Thomas (0), Ken "Lug" Thomas (0), Jimmy Youngman (2), Dave Troutman (1), and Gary Snyder (1). The excursion took place at Shady Nook in eastern Snyder County.

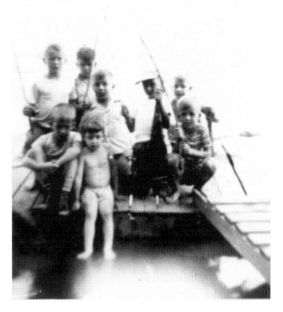

Selinsgrove Ford (previously Selinsgrove Motors), a fourth-generation dealership, has been synonymous with racing at Selinsgrove Speedway during nearly all of the existence of "the East's fastest half-mile dirt track." It was laid out by hell driver/Indy 500 racer Joie Chitwood in 1946. Providing a pace car is just one of the links. Driver Bobbie Adamson (middle) looks on as the agency's Ray Benner (right) hands the keys to a 1968 powder blue Ford Galaxy 500 convertible to raceway promoter Jack Gunn.

Al Fisher is shown with his familiar No. 19 super-modified at Selinsgrove Speedway in 1963, the year Selinsgrove resumed regular racing cards. He won the respect of fans, fellow drivers, and promoters, and more than a few races. Fisher, who raced in the 1950s, 1960s, and 1970s, was the kind of steady driver a track needs to put on quality racing programs. During his lengthy career, Fisher raced at nearly all of the central Pennsylvania tracks, especially at neighboring Port Royal and Huntingdon.

The signage leaves no doubt as to the location of this photograph. Taken in the mid-1960s, it depicts driver Paul Long, longtime promoter Jack Gunn, and Long's reliable Selinsgrove Motors semi-late model Ford. Long of Middleburg and Barry Camp of Beavertown/Troxelville were as successful as any local drivers. Long was a two-time semi-late champion and recorded 32 career wins.

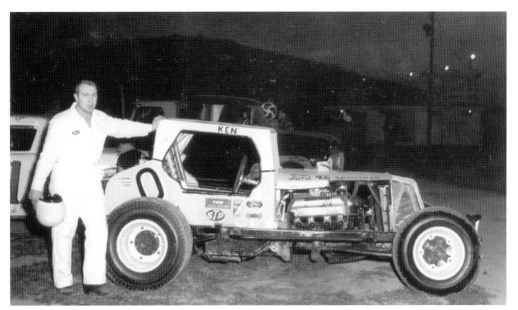

Ken Wagner of Beavertown is somewhat unique—a professional baseball player in the Milwaukee Braves system and a successful sprint car driver. Shown here in 1966, after his baseball career, he was one of the Selinsgrove Speedway's better drivers. He competed with legends Johnny Crawford, LeRoy Felty, Mitch Smith, Ed Spencer, Ray Tilley, and Dick Tobias.

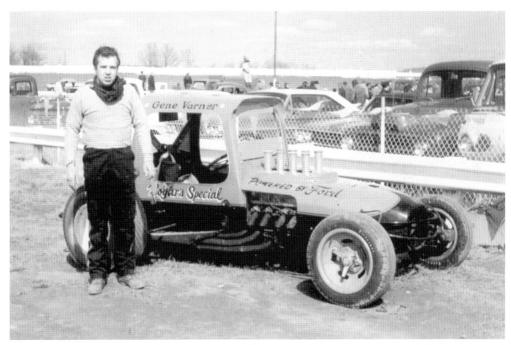

The Bogar's Special was as fine a super-modified car as there was to race at Selinsgrove—and maybe anywhere. The car enjoyed a national reputation among dirt track aficionados. Shown here in 1966 is driver Gene Varner, who is covering up the car's widely recognized No. 99.

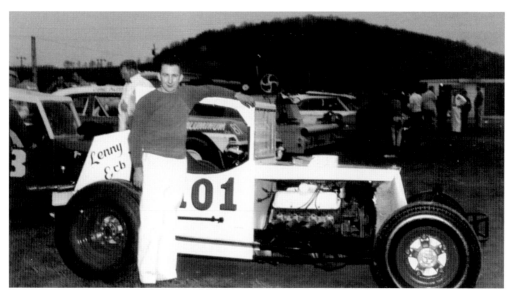

With Selinsgrove's Bake Oven Hill in the background, super-modified driver Lenny Erb of McClure poses with his No. 101 ride in 1966. Erb had a large following that was not necessarily confined to Snyder Countians. His style of driving caught the attention and gained the admiration of a wide network of race fans. Erb built his cars from the tires up. No longer a smoker, Erb was then seldom seen without a King Edward cigar.

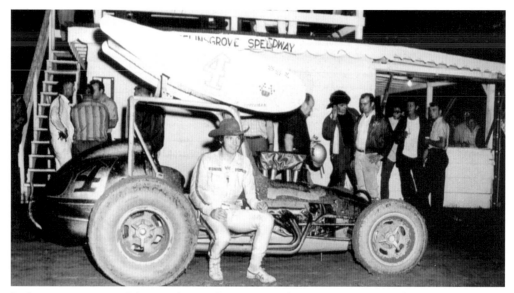

Perhaps no one enjoyed the popularity of super-sprint driver Jan Opperman, shown after winning at Selinsgrove Speedway on May 23, 1970. Opperman blew in from the Midwest like a Kansas tornado. After burning up the local track, literally sometimes, he moved up to Indy-type cars. More than once, he drove in the famed Memorial Day Indianapolis 500. He also raced on the United States Auto Club (USAC) and NASCAR Winston Cup circuits, drawing a local following to Pocono Raceway at Long Pond as well as other tracks.

OTHER GAMES ON
OTHER FIELDS

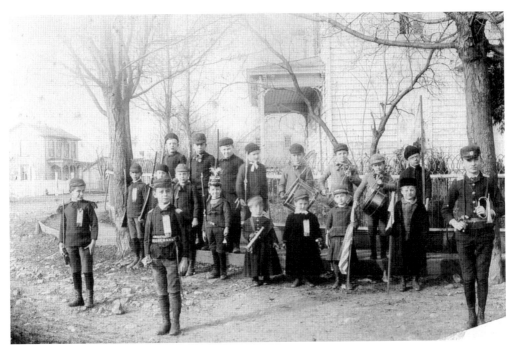

The Susquehanna Rifles of Selinsgrove pose at the East Mill Street home of the Schnure family on December 5, 1887. Shown are, from left to right, (first row) officers George Schoch, William Schnure, and Cyril Haas; (second row) John Schoch, Bruce Burkhart, Ralph Wagenseller, Silas Schoch, Marion Schoch, Mary Schnure, Carl Haas, and Artie Boyer; (third row) Rollie Boyer, Lester Hartman, Jimmie Davis, Harry Wagenseller, Howard Doebler, Billie Phillips, Reddy Phillips, and Amos Laudenslager. The unit is thought to be a precursor to the scouting movement.

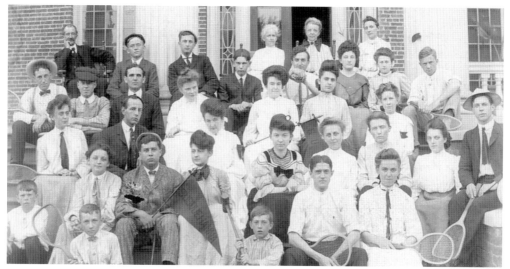

Summer school at Susquehanna University in the early part of the 20th century was a chance for younger students to get ahead and for teachers with a normal certificate to work toward a bachelor's degree. Given the tennis rackets, croquet mallet, and other fun things, it was not all pencils, books, and teacher's dirty looks. Viola Steely is shown (next to the last row, third from the right) with her fellow students in 1906. She later married Cluny Baker, longtime publisher of the McClure *Plain Dealer*.

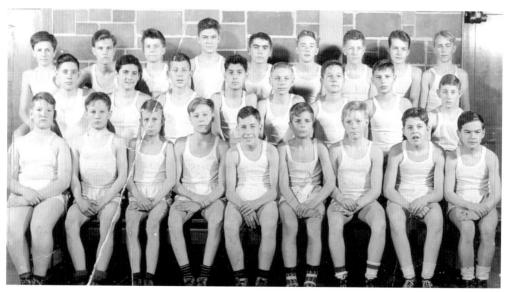

The 1941 eighth-grade gym class at Selinsgrove took part in gymnastics, naturally, and other sports. Shown are, from left to right, (first row) Melvin Inch, Glenn Shaffer, Bob Thomas, Wilfred "Wimp" Boyer, Bob Laubscher, Ken Geist, Amos Stagg III, Dick Bogar, and Ellie Rowe; (second row) Charles Gaugler, Ken McIntosh, Dick Wetzel, Dave Bilger, Grant Rowe, Bob Kuster, Bill Hummel, and Gene Bodmer; (third row) George Hepner, Charlie Parker, Jack May, Gene Valentine, Bob Kratzer, Dick Wendt, Bruce Gemberling, and Don Fisher.

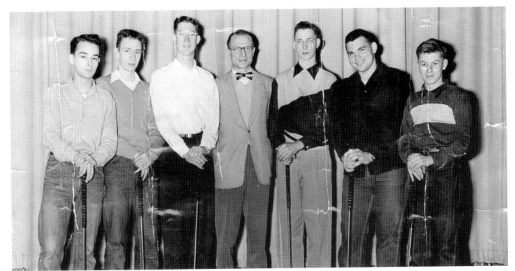

With the picturesque Susquehanna Valley Country Club in nearby Hummels Wharf, it was only a matter of time before golf became a varsity sport at Selinsgrove High School. Versatile coach Blair Heaton poses with his "linksters" in the spring of 1952. Shown are, from left to right, Nelson Bailey, Dave Richards, John Tyler, coach Heaton, Bob Tyler, Brady Munn, and Donny Heiser. Most of the team learned the game through caddying at the country club.

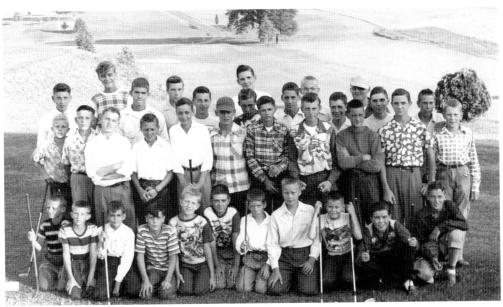

Before carts, there were caddies. Shown at Susquehanna Valley Country Club in 1953 are, from left to right, (first row) H. Emery, B. Long, L. Herman, C. Long, L. Heiser, L. Boyer, C. Heiser, R. Duncan, A. Schuck, L. Fox, and G. Walter; (second row) D. Herbert, S. Tyler, S. Munn, H. Aucker, F. Buckles, C. Herman, D. Eichenlaub, J. Emery, D. Heiser, B. Gemberling, and B. Heiser; (third row) D. Bickhart, C. LeFebre, B. Arbogast, E. Rosenblum, D. Krohn, M. Bailey, and G. Slobodian; (fourth row) E. Rowe, B. Heiser, G. Riegel, B. Gargie, and H. Pearson.

Marshall "Bud" Herman of Selinsgrove has always been something of an Ozark Mountain Daredevil. In World War II, with Gen. Jim Gavin's 82nd Airborne, he jumped out of perfectly good airplanes over Sicily and Italy. After the war, he raced hydroplanes—sometimes upside down. He won numerous races throughout the East in the 1950s and 1960s. Here he is shown racing a B-class hydroplane at Mays Landing, New Jersey, in 1956.

While students at Susquehanna University, Pross Mellon and Skip Jacobs were part of the racing scene, entering a semi-late model stock car at Selinsgrove Speedway. No pictures of that car exists, but Jacobs (left) and Mellon are shown in the mid-1960s at an Upstate New York ice race with their No. 3 Austin Healey. In the background are a Triumph TR-3 and Mellon's Buick Wildcat.

Like another basketball coach (Blair Heaton), Susquehanna University coach John Barr (extreme left) doubled as golf coach. His 1968 squad, which played home matches at the Susquehanna Valley Country Club, consisted of, from left to right, John Paterson, Whitney Gay, Ben Goode, Jim Cotner, Bill Bowen, and Tom Wolfe. Most continue to enjoy a round of golf to this day.

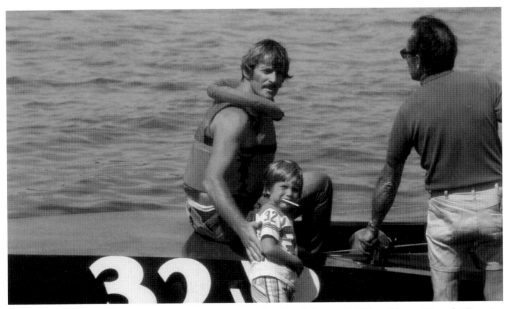

Boat racing is a generational thing with the Pontius family of Hummels Wharf. Leon "Punch" Pontius (right) won many races before putting his efforts into helping his son Don (left) become a national champion. Don, racing from Shady Nook to Seattle, won 12 U.S. championships—mostly in the C-stock Runabout class. Grandson Brian (middle) has kept up the family tradition by winning national championships of his own. This photograph is from the summer of 1973.

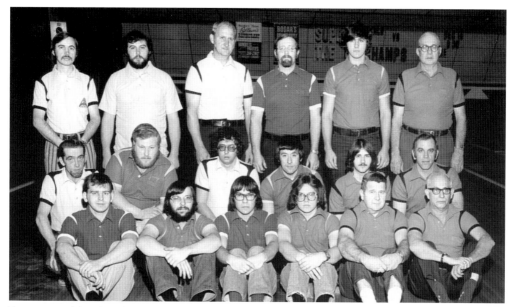

Recreational bowling has been popular since the days of Rip Van Winkle. A Wood Mode men's team of 1974 were keglers of note. Shown are, from left to right, (first row) Lewis Rapp, Roger Bowersox, Kim Rowe, Eric Rowe, Murray Mull, and Charlie Lenig; (second row) Art Wagner, Jerry Hoover, Charlie Wall III, Gene Ritter, Jerry Mull, and Jim Gill; (third row) Art Yerger, Clair Kline, Guy Yerger, Bud Arbogast, Denny Sprenkel, and Archie Shaffer. Wood Mode boasted five teams in its own league—four men's and one women's.

Motocross is, for the most part, a sport for young riders—like the Pony Express of days gone by. Motocrossers are mostly in their early and mid-teens. A highly successful rider was Selinsgrove youth Tony Yerger, pictured here in 1981 at Bellwood, near Tyrone. Yerger's No. 180 bike was kept in tip-top shape by his dad, Bob "Yogi" Yerger.

THE NEXT LEVEL

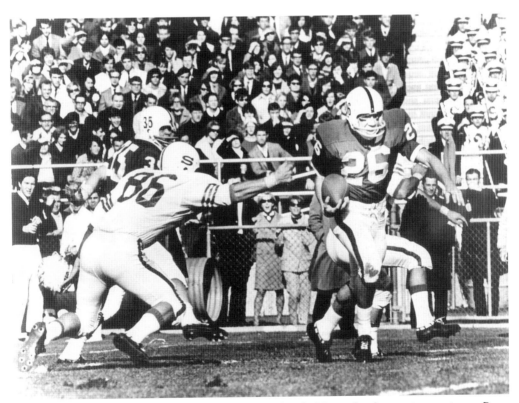

Neal Smith (No. 26) epitomizes reaching "the next level." He made a lasting impression at Penn State as a student-athlete, from unrecruited walk-on to consensus All-America safety in 1969. The Port Trevorton native and Selinsgrove High School graduate set still-standing records for single-season (10) and career (19) interceptions. To stand out on a defense that featured Jack Ham, Mike Reid, Dennis Onkotz (No. 35), Steve Smear, Pete Johnson, and Mike Smith is no mean feat, but the local engineering graduate did just that.

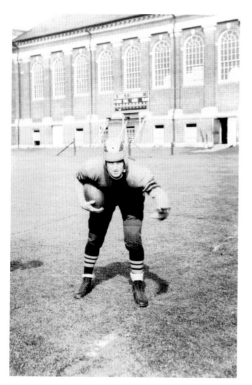

After a stellar career at Selinsgrove High School and Bluefield College, Bob Shadle—who earned the nickname "the Pennsylvania Skyrocket"—continued his explosiveness as a Gettysburg College player. A triple threat (pass, run, kick), he played quarterback and fullback for the Bullets. Shadle, who played at 5 feet 10 inches and 175 pounds, started and lettered in each of his three varsity seasons from 1934 to 1936 (freshmen were ineligible until 1973) for the "Battlefielders," as the press sometimes dubbed Gettysburg athletic teams.

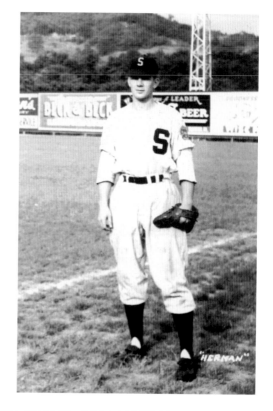

After serving in World War II and participating in the GI World Series, Sam Herman of Beavertown played professional baseball. "Sam the Man" played for the nearby Sunbury Yankees of the Class B Interstate League. He later played ball for the Beavertown Tigers of the West Branch League. Herman is shown as a member of the 1947 Sunbury club. Other stops include Hickory, North Carolina, where he had his best season in 1946 (.314 with 15 home runs); Binghamton, New York; and Springfield, Ohio.

Jack Keller of Selinsgrove High, as stated throughout this book, was as fine an athlete as the county ever produced. He became a star in basketball and baseball at Gettysburg College. He signed with the New York Yankees and played at Bristol, Virginia, for the Yankees' farm team. This studio portrait is from when he was stationed at Quantico Marine Base in 1956. After service, Keller successfully coached and taught for many years in Montgomery County, Maryland, before retiring and returning to Selinsgrove.

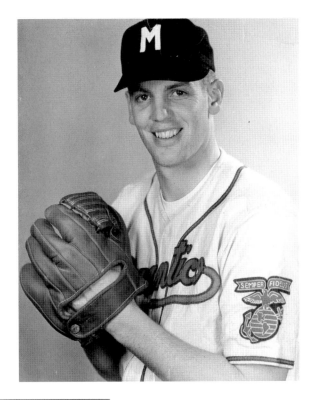

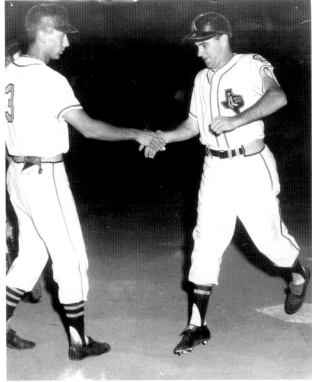

Dave Davis of Freeburg (Selinsgrove High, class of 1955) crosses home plate, greeted by an Amarillo Gold Sox mate after what he calls "one of the few home runs I ever hit." As a member of the New York Yankees organization, Davis was a teammate of such "pinstripers" as Jim Bouton, Clete Boyer, Phil Linz, Joe Pepitone, and Tom Tresh. Another minor-league mate was Ron Retton, father of Olympic champion Mary Lou. Davis played against Joe Torre and Juan Marichal in the minors, both hall of famers.

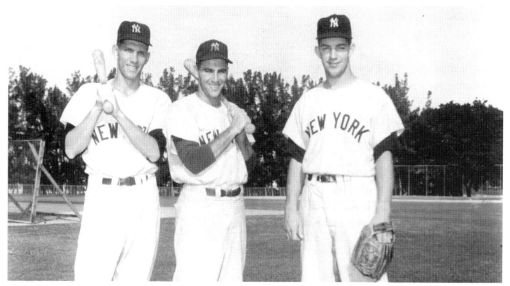

Nearly every boy's dream as a youngster is to make it to a Major League Baseball spring training camp. Freeburg's Dave Davis (middle) realized that dream in 1959, when he trained with "the big club." He is flanked by fellow Yankees prospects Phil Linz (left) and Jim Burton. Davis's minor-league career included stops at St. Petersburg, Florida; Augusta, Georgia; Amarillo, Texas; and Binghamton, New York. He played shortstop and third base and even served Amarillo as interim manager.

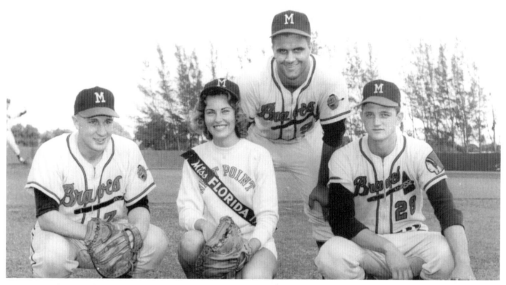

West Snyder High School's Ken Wagner (front, left) of Beavertown is another Snyder Countian who signed a professional baseball contract—as a catcher in the Milwaukee Braves system. This photograph is from "winter ball" at St. Petersburg, Florida, in 1959 after his rookie season. The others are Joe Torre (back, center)—yes, *that* Joe Torre—and Phil "Babe" Roof. Miss Florida 1959 is Nancy Rae Purvis. Other Snyder Countians with professional experience include Herb Sampsell, Mark Zechman, Gordon Arbogast, Joe Kratzer, and Dave Kelly.

THE NEXT LEVEL

Bob Walker, a tenacious center and linebacker at Selinsgrove High School, 1957–1960, enlisted in the U.S. Marine Corps after graduation. Eventually he was stationed at the Philadelphia Navy Yard. While there, he continued his rugged play as a linebacker for the semiprofessional Philadelphia 79ers—not to be confused with the NBA's 76ers. A top-notch scholastic wrestler, he grappled with considerable success at the University of Maryland after his discharge from the corps.

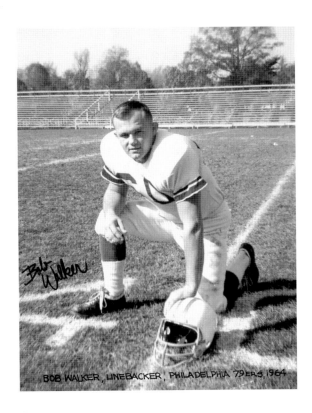

BOB WALKER, LINEBACKER, PHILADELPHIA 79ERS, 1964

With multiple Division I scholarship offers—Penn State, Pittsburgh, and Iowa State to name a few—to choose from, Selinsgrove High's Greg Aungst signed his letter of intent with Boston College in the spring of 1969. At six foot five inches, 265 pounds, he was a natural as an offensive tackle and a three-year letterman and starter for the Eagles. Aungst left his mark on the Chestnut Hill, Massachusetts, campus. As a high school senior, he earned a bronze medal (third place) in the PIAA track and field championships as a discus thrower.

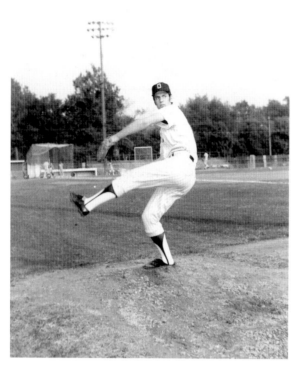

To say Rob Arnold—shown as a first-year minor leaguer at Oneonta, New York, in the New York–Penn League in 1971—was a high school "phenom" would be an understatement. His West Snyder High School record was 32-7. He struck out 317 batters, walking only 80. He paced the Mounties of head coach Jerry Botdorf and assistant coach Tony McGlaughlin to three consecutive District 4 titles, 1969–1971. At Oneonta (a Yankees farm team), he compiled a 5-3 record, a 2.56 ERA, and averaged six strikeouts a game.

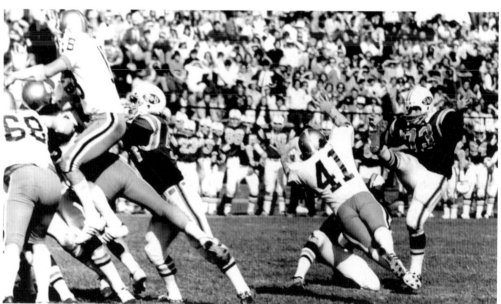

Chuck "the Toe" Smeltz was a prolific kicker at Susquehanna University from 1971 to 1974. He set an NCAA Division III record by converting 75 consecutive extra-point attempts. Those impressive numbers earned him a trip to the New York Giants' NFL training camp in 1975. However, he was unable to unseat the long-established, original soccer-style kicker Pete Gogolak for a spot on the Giants' regular-season roster.

THE NEXT LEVEL

Eight-year-old Troy Herrold of Selinsgrove, son of Kayre and Alice, reached the next level before he was out of elementary school. He was a state finalist in Ford's Pass, Punt, and Kick program and competed at a 1974 Pittsburgh Steelers game at Three Rivers Stadium. The youngster continued to do well athletically and was a fine quarterback for three seasons for Bill Scott's Selinsgrove High School Seals in the 1980s.

The next level for Selinsgrove High's Mike Fahnestock was the U.S. Military Academy at West Point. As a plebe (a true freshman), Fahnestock caught three touchdown passes in the Black Knights' opening game. When his career (1977–1980) was completed, he stood at the top of Army's list for single-game receiving yardage (186) and single-season yardage (937), and was second in career catches (97). His name is among and above such Army legends as Glenn Davis, Dan Foldberg, Don Holleder, and "Lonesome End" Bill Carpenter.

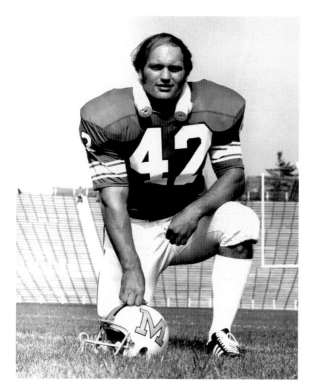

Marlin Van Horn of Selinsgrove High School was outstanding in several sports—football, wrestling, and track and field. He was state javelin champion in 1976. He accepted a football scholarship to the University of Maryland after graduation. A nose tackle, he racked up 128 tackles his junior year, 1978. Missing the 1979 season to injury hurt his NFL draft status, but he was offered a contract with the Washington Redskins. He declined and went into private business, where he has been ultimately successful.

If the gentle giant looks familiar, it is because it really is Roosevelt "Rosey" Grier, a Penn State alumnus and NFL player (New York Giants and Los Angeles Rams)—1955–1966. He is holding Janelle Ulrich while Justin Ulrich looks on, pleased to have a miniature football autographed by Grier. The ex-Nittany Lions star spoke at Port Trevorton's Grace United Methodist Church, now Hope United Methodist.

THE NEXT LEVEL

This picture of Ron Wenrich exudes power—and power was his game. As a freshman at the University of Georgia, he hit more home runs (20) than any frosh in Division I in 1985. He was named, with Stanford University pitcher Jack McDowell, the nation's top freshman baseball player. He was a No. 1 draft choice of the Cincinnati Reds. After a minor-league career, he came back to the area and terrorized baseball and softball pitchers. Wenrich's towering home run "over the church" for Middleburg High School is still talked about.

Bill Muir, who played tackle well enough to be inducted into the Susquehanna University Athletic Hall of Fame, is an NFL coaching nomad. He began with the Tampa Bay Buccaneers in 1976, then had stints with New England, Indianapolis, Detroit, Philadelphia, the New York Jets, and rejoined the Buccaneers in 2002, earning a coveted Super Bowl ring (Super Bowl XXXVII). He also spent a decade in college coaching, 1965–1975. As Jon Gruden's offensive coordinator, he is one of the NFL's most respected coaches.